34116

777.3

WITHDRAWN

D0318044

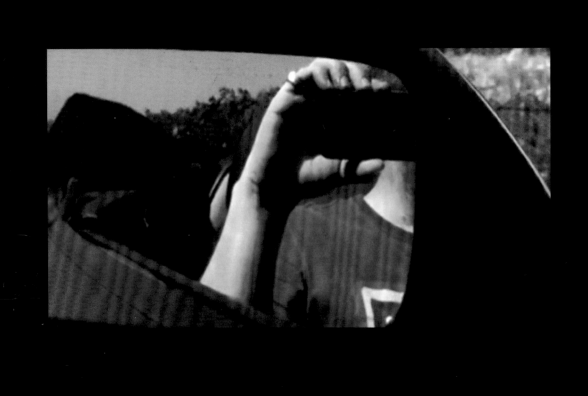

shoot, edit, and share from anywhere

Making Movies with your iPhone

3

Ben Harvell

ILEX

First published in the UK in 2012 by
I L E X
210 High Street
Lewes
East Sussex BN7 2NS
www.ilex-press.com

Copyright © 2012 The Ilex Press Ltd

Publisher: Alastair Campbell
Associate Publisher: Adam Juniper
Creative Director: James Hollywell
Managing Editor: Natalia Price-Cabrera
Editor: Tara Gallagher
Senior Designer: Kate Haynes
Designer: JC Lanaway
Colour Origination: Ivy Press Reprographics

Any copy of this book issued by the publisher is
sold subject to the condition that it shall not by
way of trade or otherwise be lent, resold, hired out
or otherwise circulated without the publisher's
prior consent in any form of binding or cover other
than that in which it is published and without
a similar condition including these words being
imposed on a subsequent purchaser.

British Library Cataloguing-in-Publication Data
A catalogue record for this book is available from
the British Library

ISBN: 978-1-907579-89-9

All rights reserved. No part of this publication
may be reproduced or used in any form, or by
any means – graphic, electronic or mechanical,
including photocopying, recording or information
storage-and-retrieval systems – without the prior
permission of the publisher.

Printed and bound in China

10 9 8 7 6 5 4 3 2 1

CONTENTS

A STUDIO IN THE PALM OF YOUR HAND

This might be a slightly strange way to begin, but I almost hope that as you picked up this book you read the title and thought "That's ridiculous!" or "This guy is crazy, the iPhone isn't good enough for making movies!" so that I'll have the pleasure of trying to change your mind.

Whether you're scanning these pages in a bookstore or reading a sample online, one way or another this title has piqued your interest. It might be because you have an iPhone and an interest in shooting movies, or it might be because you like shooting movies and have an interest in the iPhone. Perhaps you're not convinced of the claim made on the cover: that you can shoot, edit, and share professional-quality movies on

the iPhone. Or maybe you're simply thinking "I know [insert significant other here] loves their iPhone, maybe this book would be a good present for them?" If you are that person, then yes, [insert significant other here] would love this book and I suggest you make a purchase (or several) right now.

But to come back to my point, wherever in the audience you fall, I promise there's plenty of benefit to be had from this book.

When I started planning the writing of *Making Movies with your iPhone*, I looked at a few possible angles. I could have focused on the ultra-high-end techniques and big-budget productions market with the aim of showing how they could utilize the iPhone for shooting

Whether you're an amateur filmmaker, a wannabe podcaster, budding journalist, or gadget enthusiast, you're going to find out the best way to truly turn your iPhone into a powerful piece of broadcasting kit.

A STUDIO IN THE PALM OF YOUR HAND

movies. Then I considered the student filmmaker, as well as anyone who might not have the means to finance a whole set of professional kit (and who possibly doesn't realize that what they use for domestic calls is essentially a high-definition [HD] camcorder). Lastly, I thought about the vast majority of iPhone users: the people who love their iPhone, who try out all the latest apps, shoot video, take photos, and show off all the cool tricks that their device is capable of. But ultimately I realized that it doesn't matter too much— there would be a bit of something for everyone in this book. Whether you're an amateur filmmaker, a wannabe podcaster, budding journalist, family filmmaker, or gadget enthusiast, you're going to find out the best way to truly turn your iPhone into a powerful piece of broadcasting kit.

That said, this isn't a guide to the iPhone, more of a guide to harnessing it, so as you progress through the chapters of this book I'll be assuming that you know how to set your phone up, connect to a Wi-Fi network, and open the Camera app. If you run into difficulty, perhaps take a little more time to familiarize yourself with the device and all its settings before you try again. I'll be ready and waiting.

Another assumption I'm going to make is that you are using the iPhone 4, 4S, or a later model. The iPhone 4 is by no means an absolute requirement for most of the chapters in this book, but older models of the

iPhone may not be compatible with some of the applications mentioned. Also, the camera in the iPhone 4 is far superior to that of its ancestors and by virtue of the latest iPhone software, also offers better features. Similarly, the built-in anti-shake video stabilization introduced with the 4s offers a huge improvement for shooting—but more on this on page 10. In order to follow this book in style, if you're due an upgrade, try to get hold of the newest iPhone model you can. If you're not due an upgrade, why not trade in your old phone and put the money toward the new one? Gazelle.com in the US and envirophone.com in the UK would be more than happy to give you money for your old device.

But let's get back to who this book is for. This book is for anyone who wants to know how to shoot and edit video to a professional standard on the iPhone. It will explore the basics of the Camera app for shooting video, how to make the most of it, and how to push it to its very limits. It will also explore accessories, including some that are good to have, as well as some that are essential, and also apps in both categories. Yes, that means in order to get the best results you'll have to spend a little more money.

Did you hear that? That's the sound of those last few fence sitters dropping the book in disgust, or at least emphatically closing their web browser. Now it's just us: the diehards, the moviemaking wannabes, and the iPhone lovers.

THE IPHONE AS A CAMCORDER

What do most people look for when they go to buy a camcorder? Most will say that size is an important factor—the smaller the better. They will also want a viewfinder of decent size and clarity. Beyond that, they're looking for a blanket "HD quality," maybe a decent battery, and of course, the standard requirement: ease of use. It's funny then, that this description also perfectly matches the iPhone.

For starters, it's a phone, so it'll slip happily into your pocket while weighing less than a cup of coffee. A viewfinder? How about all 3.5 inches of 326 PPI Retina Display with an 800:1 contrast ratio? Not forgetting an oleophobic coating to prevent fingerprints. These are better specs than on an average viewfinder, even on more expensive camcorders. When it comes to quality, the iPhone 4 shoots HD video at 720p (1280×720 pixels) and the iPhone 4S shoots at "Full HD," 1080p (1920×1080 pixels), both at 30 frames per second (FPS). Again, some camcorders offer a higher FPS rate, but

will cost a lot more (and don't make calls half as well). The iPhone will last you all day without a charge (see chapter 2) and is almost too easy to use.

One of the advantages of the iPhone 4S is image stabilisation for video. This is a digital process rather than an optical one so it does, technically, affect image quality—the image is slightly zoomed and cropped digitally to provide the scope for jiggle-absorbing adjustments. But it really is hard to see any difference, and this feature does a lot to make shots feel much more professional and watchable. Small wobbles and shakes are smoothed out as they happen, even during handheld pans.

So, if you already have an iPhone 4S in your possession, do you really need a camcorder? Well, yes and no. Obviously a dedicated camcorder is great to have around, and if you pay a premium, you'll be able to achieve better quality video, higher frame rates, and better zoom and focus features. But as the old

Devices like the iPhone with built-in cameras brought about the demise of the Flip Video camera.

The iPhone is beginning to rival traditional HD camcorders in terms of features... almost.

THE IPHONE AS A CAMCORDER

adage goes, the best camera is the one you have with you. How often do you pop to the shops and think "I'll just take my camcorder with me in case something interesting happens?" You don't. In reality, most camcorders sit around begging to be used until you go on holiday or attend a wedding, christening, birthday party, or funeral. Well, perhaps not a funeral.

The fact that the iPhone doesn't quite match up to the feature list of a camcorder is irrelevant. The fact that it comes close is remarkable in itself. When Apple launched the iPhone 3GS—with its video recording facilities (the first time video could be shot with an iPhone)—it was reported that mobile uploads to YouTube increased by 400 percent. I wonder what percentage of those users also had a camcorder? The iPhone as a camcorder is more to do with its convenience than its quality, but since the iPhone 4, and now the iPhone 4S, its features are so close to that of a dedicated video recorder that the line between smartphone and camcorder have blurred. This is further accentuated by the fact that Cisco Systems' Flip Video compact camcorder ceased production in April 2011, largely due to competition from smartphones with cameras. The thinking of consumers at the time was, "I can shoot HD video on my phone, why do I need another device?" As the iPhone and other phones advance in terms of features, it's likely that these thoughts are turning toward full-fledged camcorders as well.

In this chapter, I want to run through the basic features of the iPhone in terms of shooting, and also point out a few tricks and a few no-nos when shooting, just to make sure we're all on the same page (literally as well as figuratively).

YouTube saw an alleged 400 percent increase in mobile video uploads after the iPhone 3GS launched.

THE TWO CAMERAS (MORE LIKE ONE-AND-A-HALF)

There is something we need to clear up right away. When I talk about the iPhone's camera in this book, I am referring to the one you find on the back of the device, and not its inferior smaller sibling on the front. The sort of camera whose parents refer to it as "the black sheep," the front-facing camera is designed purely for video chat and self-portraits, hence its lesser VGA-quality output. Do not be fooled into using this camera for real shooting, even if you accidentally hit the "camera switcher" on the Camera app's screen. The iPhone's screen should always be facing you when you film— remember it that way.

ZOOM FEATURES (CAN'T DO IT, DON'T DO IT)

To fully understand the shocking comment I'm about to make, I first need to explain a little something about zoom. We all know what zoom does—effectively it helps us get closer to, or farther away from, a subject we are shooting. However, there are two basic kinds of zoom out there. The first is physical (or optical) zoom that requires an adjustable lens to change the focal length. To me and you that's still "getting closer or further away" in a visual sense. The iPhone doesn't have an optical zoom: it uses digital zoom, which relies on the adjustment of the image and not the lens, with a little bit of interpolation (digital guesswork) thrown in. Digital zoom is, for the most part, the same as cropping a picture on your computer. The more you crop the closer you get to the subject, but the quality deteriorates as you go. This is why I recommend never using the iPhone's digital zoom unless you absolutely have to. Fortunately, the zoom option isn't currently available for video, but as we'll talk later about including photos in your movies, I thought it was worth mentioning.

Think of it like this: if you shoot zoomed out, you might be able to zoom in later when editing, while if you shoot zoomed in, you've condemned that image to a life of being eternally zoomed in. It's not fair on your photos.

It seems Apple, like I, thinks digital zoom is a bad idea for video and hasn't included the feature in its most recent updates for the iPhone software. If, for reasons beyond me, it one day does, don't be tempted to use it. Due to its portability and compact size, the best method of "zooming" when shooting with an iPhone is by using the time-honored technique of physically moving closer to, or farther away from, your subject.

Digital zooming on an iPhone.

FLASH (BRIGHTEST ISN'T ALWAYS BEST)

You've seen the setup before when you've been given a glimpse behind the scenes of film shoots in documentaries and DVD extras: the giant lighting rig shining down from behind the camera. It's all very impressive, and a necessity in order to get the correct light on a shot. Relying on the weather is never a professional director's plan—film professionals tend to create their own. The iPhone's flash allows you to do much the same, but you must appreciate it's a matter of perspective. Whereas a movie set requires a massive light to illuminate the scene in front of large cameras, you have a small light and a small camera. Unless light from the iPhone's flash is actually hitting the subject you are shooting, it's pointless, and could even be reducing the quality of your footage. Unless you are getting very close to your subject or are shooting at night, the chances are that the iPhone flash won't make much of a difference. You can use it to attempt to brighten up a shot on an overcast day, but it'll have to be a matter for your judgement and used on a very close subject and not, for example, on a landscape shot.

Similarly, when shooting in the dark don't expect to fill the room (or even the shot), with light when using the iPhone flash. Again, if using the flash you'll need to get up close to your subject to make sure they're lit.

The iPhone's flash can be turned on and off as you wish while shooting by tapping the flash symbol on the camera interface. It also offers an automatic mode, which is more for photos than it is video. The benefit of turning the flash on and off mid-shot is limited, though it could be used to create a very basic "reveal" effect or a horror movie-style lightning flash if you want to get really creative. You know the effect—a dark, empty room, and then flash! Lightning strikes and a face appears at the window. It'll look more *Evil Dead* than *Psycho*, but it's a fun trick nonetheless.

Turning the flash
on and off mid-shot
could be used to
create a very basic
"reveal" effect or
a horror movie-style
lightning flash if
you want to get
really creative.

FOCUS AND EXPOSURE (SEE MORE OF YOUR SHOTS)

One thing the iPhone's camera does very well is working with exposure and focus. The interface is a breeze to master, too. For example, let's say you are shooting some people standing at the front of a crowd. The iPhone will do its best to focus on what it thinks you're trying to film, but at the end of the day, it's a phone and hasn't really a clue. In order to identify the intended subject, all you need to do is tap on the screen while aiming at it. Once this information has been received, the iPhone makes this area the focal point, reduces the focus on everything else, and adjusts the exposure to better capture your subject. What's even better is that this can be done while you're shooting so you can shift the viewer's attention mid-shot to another subject. Unfortunately, it's often not the smoothest of transitions, and you might need

a few takes to perfect the focus shift. The same technique can be used for adjusting exposure and produces another nice effect of dark-to-light, or vice versa. For example, when focused on a very bright subject—say a sunny window or even the sun itself—the background disappears into almost blackness. If, while shooting, you tap an area of the background, the exposure and focus shift completely, and you can see the entire scene.

In the pictures on the right you can see the difference the focus and exposure settings make when shooting, especially in low light or when there are very bright points within your shot. As much as it might look like these two sunrise shots were taken hours apart, they are actually both taken from the same clip, only a few seconds in length.

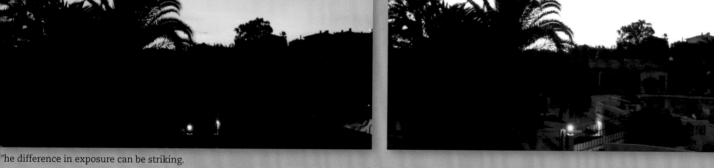

The difference in exposure can be striking.

STORAGE (SAVE THAT SPACE)

Needless to say, HD video produces larger file sizes than standard definition video, which means you'll need quite a bit of free space on your iPhone. If you own the 16GB model things might begin filling up quickly, so if you're serious about your shooting consider getting rid of your music and movie library to make sure there's enough storage available. The last thing you want is to see the dreaded "out of space" message when you're about to capture the most incredible thing you've ever seen. 32GBs will be a decent amount of room to work with, but 64GBs is obviously the best option. If you don't know the capacity of your iPhone, take a look at the box or head to the Settings app and look under *General > Usage* to see what you're using and how much space is left. There is of course the option to store your files remotely, and I'll touch on this topic later in the book. The problem with doing so though is that you'll need to re-import clips from the web in order to use them with iMovie on the iPhone.

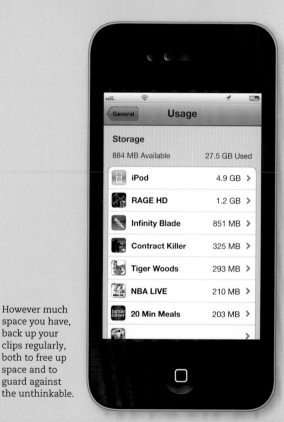

However much space you have, back up your clips regularly, both to free up space and to guard against the unthinkable.

The last thing you want is to see the dreaded "out of space" message when you're about to capture the most incredible thing you've ever seen.

PLAYBACK (PREVIEW AND REVIEW)

The iPhone is a great preview tool for your recordings with its high definition Retina Display, and playing back movies from the Camera Roll offers a good view of your video at its best. Sometimes, it's almost too good. It's certainly worth checking movies on a TV or computer display as well to make sure you're not being fooled by the clarity of the iPhone's screen. The easiest way to do this is via AirPlay, Apple's built-in wireless streaming technology. If you have an Apple TV connected to your television (which, to benefit fully from some chapters, you should) you can quickly select it on your iPhone and send video clips to a much larger display. The other benefit of this method is the ability to more accurately gauge the sound in your video. The iPhone's microphone does a good job of picking up audio, but the speaker leaves a lot to be desired. If you don't have an Apple TV, exporting your clips back to a computer will be required. This can be done via iPhoto on a Mac, or via simple USB import on a PC. The other option, if you only want to check out a handful of clips, is to email them to yourself and access them on your computer.

Previewing on the iPhone is almost too good. It's certainly worth checking movies on a TV or computer display as well to make sure you're not being fooled by the clarity of the iPhone's screen.

Camera Roll offers a great view of your videos.

BATTERY LIFE (AND HOW TO EXTEND IT)

Things have come a long way since the first iPhone in terms of the device's battery life. It is, however, still a struggle to keep the iPhone running for a full day if you're performing fairly processor-intensive tasks. Unfortunately, shooting and editing movies is one such task. If you were to record for half a day, the chances are you would need a recharge before long, and for that reason I've included a section on charging accessories later in the book. From solar power to cases with built-in batteries, there are some ideal options for the traveling iPhone *auteur*.

There are ways to extend the life of your iPhone battery without using an additional power source, but they do require some compromises. The first is simple: turn off your 3G connection from within the Settings app and only turn it on when you need to use a fast data connection for transferring movies or sending email. This will save a great deal of battery, and while you're shooting, you shouldn't need the faster Internet speeds. If you're not bothered about geotagging your video clips (which can provide you with some unique editing features) you can also turn off Location Services, which will also save some valuable juice. Then there's the brightness of your screen. The very bright and high-quality display sucks power like there's no tomorrow: the dimmer it is, the less charge you're wasting. Of course, shooting movies with the screen dimmed to an almost unviewable degree isn't ideal, and you also won't be getting accurate feedback as to what you're shooting, making things even more difficult. You could, if you have the patience, dim the screen while shooting and then increase the brightness when you review your shots, but this will quickly become tedious.

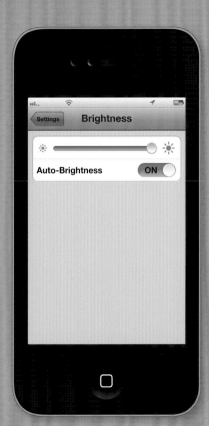

In a tight spot changing the Brightness settings can give you more battery to play with.

From solar power to cases with built-in batteries, there are some ideal options for the traveling iPhone *auteur*.

SHOOTING ACCESSORIES

So that's the basics covered, but we're not ready to get out there and shoot just yet. First we need to take a look at a few extras that you might want to add to your filmmaking arsenal. I'm well aware that you've already bought an expensive iPhone and (I hope) this book. (Actually, if you're still reading this in a shop, it's almost certainly time for you to make a purchase. In fact, the staff are probably eyeing you from afar making tutting noises under their breath.) Anyway, if you're looking to produce the best quality video, at least a couple of these items will be well worth the money when you come to consider the finished product.

I'm not talking about bank-breaking amounts, either. Most of these products are available from amazon.com and other online retailers, so you're likely to find them cheaper than the recommended retail price. You can also try googling them and then clicking the Shopping link to the left of the results. I've found some serious bargains this way. But this isn't a book on the benefits of online shopping, so I'll move on to explaining just what you should be spending your money on in order to perfect your iPhone moviemaking experience.

STANDS AND TRIPODS

You can easily shoot an entire movie on your iPhone without any form of stand or other support for the device. However, you will also fall victim to those shaky, amateur-style shots that won't benefit your film unless you're making a follow-up to *The Blair Witch Project*. Finding ways to steady your iPhone while shooting is essential for a polished finished product, and if you're filming a stationary subject, simply resting your iPhone on a flat surface could well be all you need to avoid the wobbles of handheld filming. That said, the selection of tripods and stands I've assembled on the following pages are ideal for turning wayward clips into steady shots that Scorcese would be proud of. Tripods also come in handy when filming different types of video, such as time-lapse and stop-motion, that require the camera to be kept in exactly the same position for long periods at a time. Get yourself one of these bad boys and your audience will thank you.

Top Tip: Tilt and pan

When deciding on a tripod or stand, consider its uses. If you're happy to have it sitting in one position for time-lapse or event shots you shouldn't have to worry, but for more detailed and creative work, consider spending more money on an adjustable tripod. With an attached handle and pivots, a tripod can make it easy to shoot silky-smooth panning shots or create unique tilted angles while keeping the iPhone stable.

Steadicam Smoothee

A problem with the filmmaking process is that movement makes shots great, but camera-shake ruins shots. So how do you smooth out the camera's movement while being free to move the camera as you want? The now-legendary Stedicam, Garrett Brown's 1976 invention which earned him an Academy Award and a very handy patent, does just this, and excitingly enough his team have now applied that patent to a special Stedicam for the iPhone. Place the camera in the bracket, hold the handle with both hands, and softly direct the camera with tiny movements to the control plate above the gimbal. (Practice makes perfect.)

The Glif

If you already own a tripod, then there's a brilliant little tool that'll bring some balance to your movies. The Glif (available from studioneat.com) is amazingly simple yet incredibly effective, working as an iPhone mount as well as a cradle for attaching the phone to a traditional tripod. The device simply clips on to your iPhone and positions it at a convenient angle in portrait or landscape position. When you're ready to shoot, simply screw in the tripod and you're ready to go. This inexpensive little device is certainly something all iPhone users should consider adding to their kit.

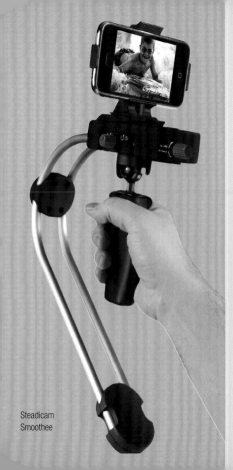

Steadicam
Smoothee

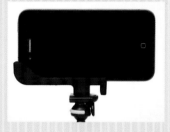

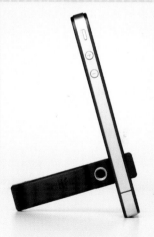

The Glif

STANDS AND TRIPODS

Joby Gorillamobile

One of the best tools I've found to help steady shots is the Gorillamobile from Joby (available at joby.com). These clever tripod and stands have been available for compact cameras for a while and have now been made available for the iPhone market. Effectively a more flexible mini-tripod, the Gorillamobile snaps on to your iPhone and allows it to be positioned in multiple ways. The three legs are almost endlessly adjustable and capable of all sorts of positions, as well as being able to hook onto and wrap around objects for more audacious angles. For example, you could wrap the spider-like legs of the Gorillamobile around a hanging tree branch and shoot from above without risking life and limb dangling from an unsteady limb yourself. You can even wrap this unique accessory around your wrist for a less wobbly panning shot. The Gorillamobile is lightweight at around 50g, and due to its polycarbonate structure, is nigh on indestructible too. The device comes with its own iPhone case that you can leave on permanently, if required, and caters for portrait and landscape orientation. Aside from outlandish outdoor shots, this kind of tripod is also ideal for close-up work and even stop-motion animation and works as well on a table as it does out in the field.

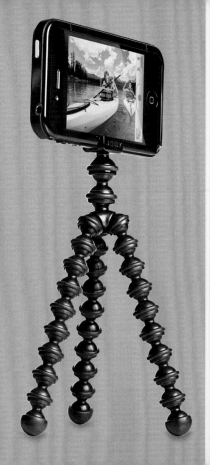

XShot iPhone Case

The XShot iPhone case, available for the iPhone 3 upwards, is a handy plastic case that attaches to any existing tripod, mount, or monopod you may have through its universal adaptor with a 1/4 inch screw. The case is made from durable plastic and comes in two parts so you can quickly attach other devices such as docking stations and speakers to your iPhone. The XShot works in portrait and landscape mode and is an ideal purchase if you're using more than one tripod. It also comes with its own mini tripod. Find out more at xshot.com.

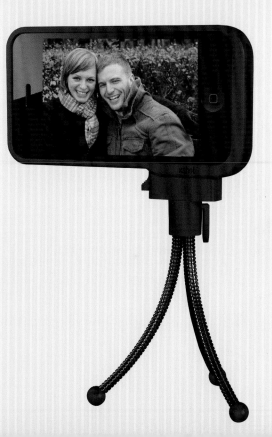

LENSES

As I've already mentioned, the iPhone's lens is pretty much "what you see is what you get." If you need to zoom, you have to move closer, and if you can't move closer, you'll have to work with the shot you've got. That is, unless you make use of an additional lens attached to your iPhone. It sounds like overkill, but if you add up the cost of the lens together with that of your iPhone you're still not quite up to the cost of an HD camcorder. The lenses I'm about to discuss are a must-have for those serious about proper filming with their iPhone and open up a new world of creative options, from macro shooting and improved focus to long-range shots that you simply can't achieve solely with the iPhone. Combined with a traditional tripod, a lens like this takes your shooting to the next level and also offers you a lot more flexibility when it comes to planning scenes and setting up shots. We're not just talking about zooming either—there are also lenses available that offer 180° fish-eye shots as well as macro lenses for picking out very fine detail in close-up shots.

Top Tip: One ring to rule them all

Don't get carried away just because you can fit multiple lenses onto your iPhone. Use the effects they produce sparingly in your project and only to benefit your recording. Shifting from one scene shot with a fish-eye lens, to a macro close-up, followed by a heavy zoom will likely confuse your audience and make them feel that they're watching a music video. Of course, if you're intentionally shooting MTV-style, feel free to switch those lenses.

OWLE Bubo

Despite the amusing name, this addition to your iPhone makes it as close to a professional-quality recording tool as it can get. Comprising a 37mm lens and external microphone, all you need to do is slide your iPhone into the housing and you're ready to shoot. The lens is capable of wide-angle shots as well as macro for fine detail, which gives you a number of options. You can even swap the lens for alternatives by simply screwing them into place. As well as providing enhanced audio and visuals, the Bubo will also help you to keep your shots steady with a clever handle at the rear for you to grip while you record. The Bubo is also quite weighty, which rather than being a burden, actually makes it easier to hold steady. With mounting points at the bottom of the device you can quickly attach your iPhone and Bubo to a tripod for the ultimate in iPhone filming, and there's even a cold-shoe mounting point for attaching additional kit like lights and larger microphones. Check out the rest of their range at almlive.com.

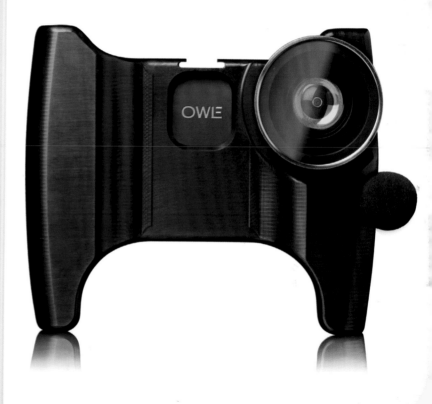

SHOOTING ACCESSORIES

LENSES

iPhone Telephoto Lens

This lens really does make your iPhone look a bit crazy, but it's worth the odd looks. Offering the equivalent of a 500mm lens on a standard 35mm camera, it also comes with a mini tripod and case for the lens to attach to. Balance is the key to using this device as the lens sticks out quite a long way, but when all is working as it should you'll be able to achieve some decent optical zoom. Like a standard telephoto camera lens, this accessory also offers manual focus by twisting the focus ring. It's available from the lovely people at photojojo.com.

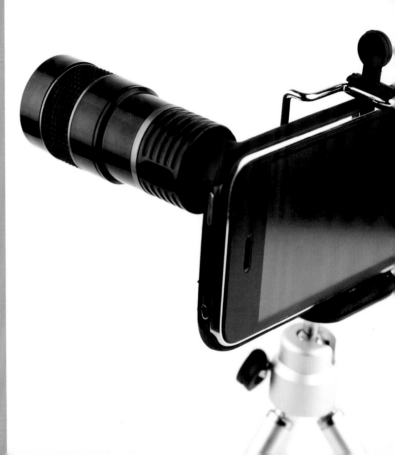

Magnetic wide-angle and macro lens kit

This is a clever lens set that's a little cheaper than the others in this section and offers a range of options for iPhone video. Available from usbfever.com, the kit comes with both a wide-angle and macro lens that attaches via a small magnet. For a minimal price, you get two lenses for the price of one as part of this kit, so you have wide-angle shots and close-ups covered with one purchase. While you don't have the option to adjust the zoom or focus using these lenses, for a low price they'll offer you some useful new features for your shooting.

LIGHTING KITS

Even when shooting with the iPhone, lighting is essential, and the built-in flash of the iPhone doesn't quite cut it. If you want to make sure your shots are bright and vivid, a small lighting rig will be necessary. The size you go for will depend on your needs and budget with prices running from affordable all the way up to thousands of pounds. You can also try some more cost-effective options using items you own already; for example, desk lamps and reflective materials like tinfoil can really help bounce the right light in the direction of your subject and may be all you need to get the illumination right.

Of course there's no simple way to attach lights to your iPhone for use on the move, but the OWLE Bubo we mentioned earlier does allow for additional attachments, and its standard-sized mount points should cater for most video and camera accessories, including lights.

Take a look at the options that follow: they will really help bring your video out from the darkness.

Top Tip: Stay cool

Large lights get hot very quickly, especially if you are using more than one in a confined space. Take special care when moving your lamps if they've been on for a while, and also avoid putting devices or filters too close to them. Where possible, use fans (very quiet fans) or ventilate your shooting space to minimize the temperature.

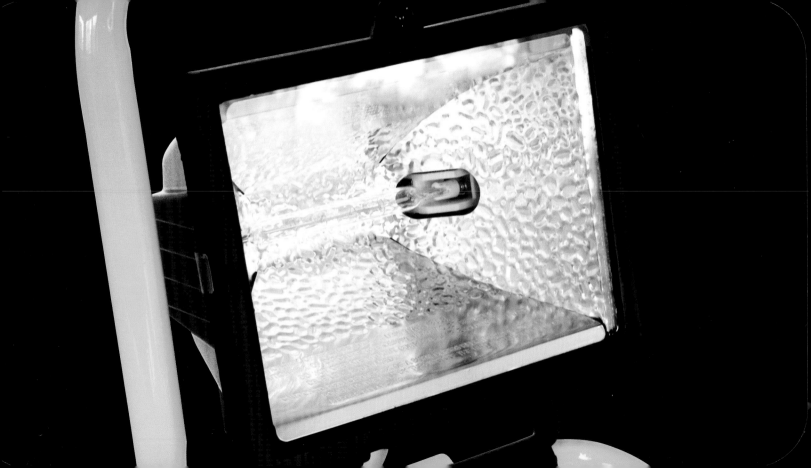

LIGHTING KITS

Mounted lighting

If you're using a tripod or case that accepts additional accessories, almost any light designed to work with a camera or camcorder should attach without problem. The ideal attachment will be compatible with hot- or cold-shoe mount points as these are the most common attachment types for visual peripherals. Should you want to opt for this route, there are a number of inexpensive lights you can use. A quick search on amazon.com will bring up a bunch of lamps of this kind with many starting at around fifty dollars.

It's also worth looking at whether or not the lamp you choose offers filters to change the lighting effect. Diffusers make for less harsh light in your footage and may be preferable to a direct flood of brightness on your subject. An additional benefit to mounted lights of this kind is that you don't always have to have them attached to your iPhone. Using the same attachment, you can also hook them up to a tripod for use as a standalone light source.

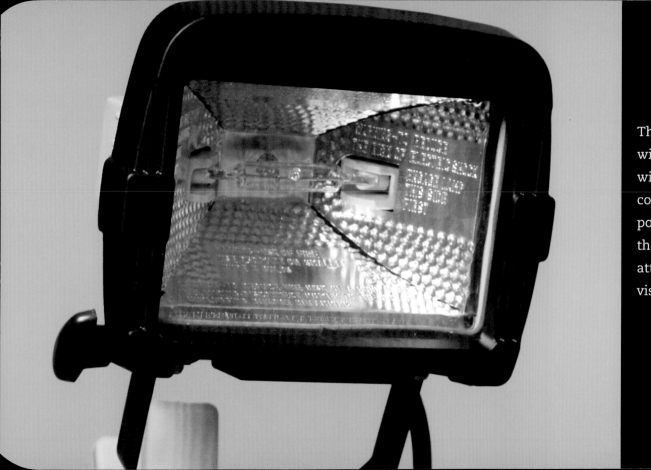

The ideal attachment will be compatible with a hot- or cold-shoe mount point, as these are the most common attachment types for visual peripherals.

LIGHTING KITS

Reflective lighting

Sometimes it's not about a lack of light in your shot, but the direction of it. In this case, all you need to do is harness the available brightness to make it work for you. This is where a light reflector comes in. Light reflectors are essentially lightweight circles of fabric with a reflective front that are used to direct light to a subject and eliminate shadows. By bouncing sunlight or light from a lamp onto a reflector, and so onto your subject, the light is focused to produce a highlight which will add a more professional feel to your shot. Light reflectors come in a variety of styles and colors to suit your needs with white and silver being the most popular. In order to direct light with a light reflector, you'll either need a stand or a helpful assistant to hold it in place while you film. If you're shooting indoors, it's best to use a light reflector with a direct source of light rather than the room's own lighting, so consider buying a tripod-mounted lamp, or if money is a factor, a simple desktop lamp with a positionable head will do the trick.

It's more than likely that you'll be able to find kits that include a stand and selection of reflectors for a reasonable cost online, and Amazon and eBay are good places to look as well as, of course, your local camera shop. Being lightweight, most reflectors can be folded or collapsed into a very portable form, small enough to throw into a camera bag if you're heading out to shoot on location. When you're ready to use a light reflector, it simply springs out into its default shape and is ready to go.

Light reflectors are essentially lightweight circles of fabric with a reflective front that are used to direct light toward a subject and eliminate shadows.

LIGHTING KITS

Standing lamps

The lighting you see on movie sets doesn't come cheap, but there's no reason you can't get hold of your own budget alternative. Most good hardware stores offer work lamps, normally complete with halogen bulbs and a stand, at a very low price. This is the kind of lamp you see next to nighttime road maintenance or workshop desks. Don't be put off by this. At the end of the day you want light for your shots and as much of it as possible. For as little as twenty-five dollars you can get yourself a nifty little light source that can be positioned as you like and will bring about a huge increase in brightness to your shots. The drawback is that these lights can be a little too bright and therefore bouncing the light off a reflector or even a nearby wall will be necessary to soften things up a bit. Also, you'll need to be careful, as these lights can be extremely hot.

Some lights of this type even come with two lamps attached so you have a great deal more light or the option to bring the light level down if you wish. Head to your preferred online shopping retailer and take a look at professional lighting rigs compared to these cheaper alternatives and you'll see my point.

Of course if money's no object, then there's no reason not to go for the more expensive lighting solution. If this is the case, look for stands that can be adjusted height- and tilt-wise as well as those that offer additional grips and mounts so you can attach more lights or filters. Some "professional" (read: still fairly consumer-focused) studio lighting systems even include their own light diffusers, and you can pick up a lighting kit complete with two lamps and diffusers for just over a hundred and fifty dollars if you shop around.

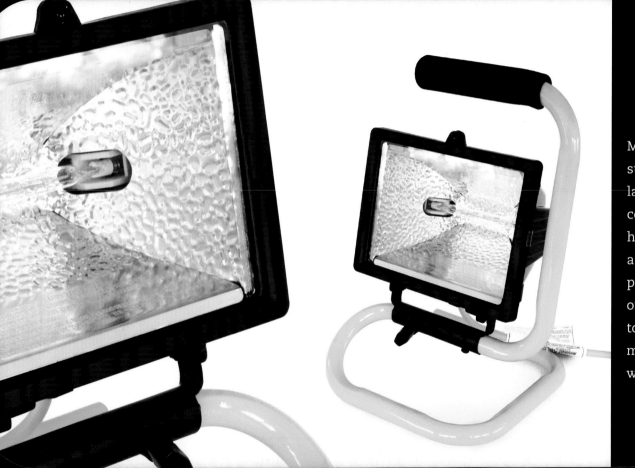

Most good hardware stores offer work lamps, normally complete with halogen bulbs and a stand, at a very low price. This is the kind of lamp you see next to nighttime road maintenance or workshop desks.

MICROPHONES

Sound quality really can make or break a recording. I'm going to be presumptuous here and guess that you're not planning to record sound separately when you shoot your movie. If you are, good luck to you and I assume you know how to sync the footage and audio together once you get both back to a computer. If you don't, maybe it's best to try it first the standard way, through the iPhone's audio input.

I'm not a big fan of the iPhone's built-in microphone. Apple did upgrade it for the iPhone 4 and introduced a second mic dedicated to noise cancellation, but it seems the plan was to improve phonecall clarity rather than to improve the audio in recorded video. When shooting, the iPhone's microphone falls victim to wind noise, and as a result of it being positioned within the device's housing, it isn't directional, meaning it will pick up all manner of unwanted background sound over the audio coming from your subject. It's just a phone after all, right? Wrong, if you're serious about recording good quality sound, all you need to do is connect a compatible microphone to the headphone jack and the device will happily use it to accept audio instead. There are a number of different mics available that will play nicely with your iPhone for video recording—the question is what type of recording will you be doing? If you're shooting an interview, a simple corded, desktop, or handheld microphone will do. If you're recording a piece to camera, a lapel microphone will be your best bet. If you're shooting an event or live performance a shotgun microphone is a useful addition, and finally, if you're shooting a full scene, it's worth looking into a boom mic.

I've outlined the major microphone types below and suggested a few that work very well with the iPhone 4 so you can pick out exactly what you need for a sensational sonic solution.

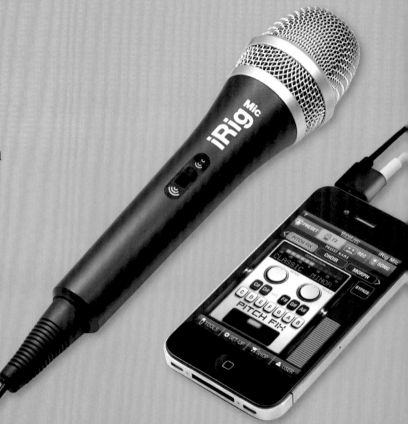

MICROPHONES

Handheld microphones

The standard microphone for simple interview work, a handheld condenser microphone is an inexpensive way to improve the audio quality in your recordings. Lightweight and flexible, you can shoot with one hand and hold the mic with the other, or enlist the help of a "sound assistant," who'll only need the ability to extend their arm toward your source. For this kind of recording I've enjoyed working with IK Multimedia's iRig Mic, which is aimed at the music market, but works perfectly for video too. With a very pocket-friendly price and design, the iRig Mic offers a three-way gain switch, which in layman's terms means it can be set to work in close-up or at a distance. It also slots nicely into a standard microphone stand so you can mount it if you need to.

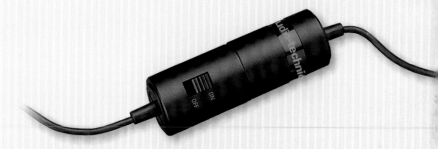

With a decent length of cord running from the microphone to the iPhone, you are also provided a great deal of flexibility and movement. Perhaps one of the best features offered by the iRig Mic is its monitoring. Because microphones attach to the iPhone's headphone socket, using headphones isn't normally an option, but using the dual mini-jack connector of the iRig Mic, you can listen to your recording through headphones in order to monitor it. Again, this could be a job you give to your trusty sound assistant, or take on yourself. Being low priced, this mic is ideal for those on a budget, and can be substituted for any of the other mics we're about to consider. Whether you hang the mic from a convenient position, tie it to a pole for use as a makeshift boom, or give it to an actor to hold out of shot, it'll be up to the task.

Lapel microphones

Lapel mics are the unsung heroes when it comes to recording television interviews and other pieces to camera. Well hidden, yet still capable of picking up all audio detail, the tiny mic is attached to clothes with a small clip and—you guessed it—placed on the lapel, the usual position used due to its proximity to the mouth and throat. Professional broadcasters normally use wireless lapel microphones, but for the purposes of our recordings, a mic with a decent length of cable should be good enough.

MICROPHONES

Incidentally, you would be forgiven for thinking that the iPhone's own headphones could work in this way given the fact that it offers a built-in microphone. The problem is that without a clip it's hard to position and picks up a lot of unwanted noise from clothes and the environment, and is particularly sensitive to wind. Using a dedicated lapel microphone will provide a degree of protection from this interference and will also allow you to be more creative with the positioning of the microphone. Of course, you're welcome to give the iPhone's headphone mic a go, but it's unlikely you'll achieve the best results. Take a look at Audio-Technica's Lavalier Condenser mic as a suitable lapel option that comes with a clip, wind shield, and adaptor, but not the hefty price tag of some other mics of this kind. It also offers a 20-foot cable so your subject has freedom to move and doesn't need to be positioned inches from the camera.

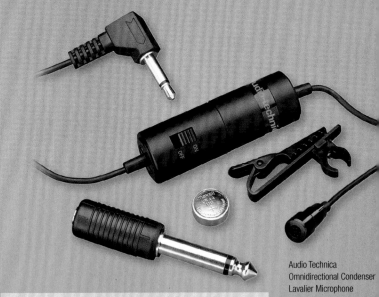

Audio Technica
Omnidirectional Condenser
Lavalier Microphone

Top Tip: Microphone mishaps

When shooting with an external microphone, interference can quickly ruin your sound. Make sure that you switch the iPhone into Airplane mode when shooting (do this from within the Settings app) and avoid shooting too close to power lines or any other electronics or radios that could mess up your audio.

Shotgun microphones

You'll have seen shotgun microphones attached to larger video cameras, the kind that stick out in front of a camera and work as an alternative to a boom or handheld mic. These devices are best used when capturing an overall sound while you record video, but given that the microphone is pointing in the direction of the subject of your shot, they do allow for a degree of sonic focus as well. In the case of the iPhone, a shotgun mic is a difficult prospect as there's little room for it to be positioned before it begins interfering with the shot. You have roughly two inches to play with when it comes to a microphone pointing forward from the iPhone due to the fact that the headphone/line-in port is positioned at the same end of the phone as the camera, and as with most peripherals, their size is proportional to that of the iPhone itself. This is true of the VeriCorder Mini Mic for iPhone 4 which connects quite happily to the headphone port of your iPhone and can be positioned in any direction you wish without appearing in your shot. This mic isn't designed to capture loud sounds like concerts and street scenes, but will work well when capturing subjects at close range in fairly quiet environments. For a more advanced shotgun mic, take a look at Audio Technica's ATR-55 Condenser that can work from batteries and offers a mini-jack connection as standard. It won't mount on your iPhone, but can be attached to a mic stand or used as a boom mic as needed. This is of course a more expensive option, and unless you absolutely need the features of a more advanced shotgun mic, you're better off sticking to a device like the VeriCorder that attaches to and mounts on your iPhone. Back in the section on lenses I mentioned the OWLE Bubo which provides its own shotgun mic but is also capable of attaching others, so this could work out as a decent solution if you want to use a larger mic when shooting.

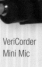

VeriCorder
Mini Mic

SHOOTING ACCESSORIES

MICROPHONES

Boom microphones

Useful for recording audio on group conversations, if you see a boom microphone in shot it usually means that someone on the production team has messed up. You would have a hard time trying to find an iPhone-dedicated boom microphone—in fact I would go as far to say that there aren't any. Few manufacturers are willing to enter into such a niche market, so a simple handheld or shotgun mic is the closest thing you'll find to total iPhone compatibility. That said, you can quite easily transform an existing mic into a boom mic with the right length of cable and a decent boom pole, which you can source for minimal cost. There's also the option to buy a professional-quality boom mic and use an adaptor to send input to the iPhone. Ultimately, a boom mic is just another microphone, and it should be directional (like a shotgun mic) so you can aim it at specific subjects and reject sound from other sources, but this can be easily achieved without buying a specific device. Look at what you already have and

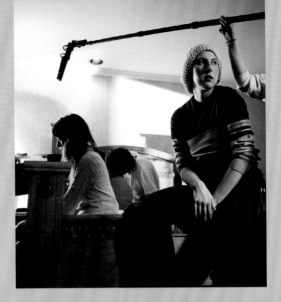

Making your own iphone-compatible boom mic is the best option for the amateur moviemaker.

make a decision based on how often you'll realistically use a boom mic by comparison to the microphone options I've mentioned. If you don't believe you'd use it a great deal, then you might be best served by buying an extender to use with your existing mic when you need it.

A little more on microphones

While I've run through the basics of the iPhone microphone options and pointed out a few gems for you to consider, the truth is what works for you is the best way to go. If you can make do with using the standard iPhone headphones as a lapel mic or you're happy to take your chances with the iPhone's built-in mic, then go for it. Just be aware that this may result in your video looking vibrant and your audio sounding awful.

 You should also investigate the possibility of using any microphones you already own with your iPhone. With the right kind of adaptor a number of mics will work as an input for your iPhone without necessarily being "iPhone compatible." You can also use a bit of cunning when it comes to your requirements. For example, rather than using a boom mic to record two subjects talking, you could hook them both up with a lapel mic and use a splitter cable (such as the Monster® iSplitter) to run the input from both mics into your iPhone. The best method is the one that provides the highest quality recording while being both cost-effective and simple, so bear that in mind while you set up.

 You also shouldn't be afraid to mix things up. Now, by this I don't mean change mics for each shot, that's going to make things sound very strange, I simply mean that you should try a number of microphone setups and positions before you decide on one. The traditional route isn't always best, especially in the guerilla-style world of iPhone shooting.

CHAPTER 3

THE LANGUAGE OF FILM

It's all too easy to feel like you know what you want from your movie, only to wish you had gone down a different route when it comes to editing it, or in the worst case, screening it. That's why it's paramount to be completely clear on your movie's message and style, and give yourself a better chance of achieving it with proper planning. Considering your audience is of key importance, as well as the medium you choose, and the running time of your finished film. Again, the latter will be dependent on your medium and intended audience. It's more than likely that you'll be working on a movie for the web or DVD, but cinema screening isn't out of the question with the HD footage you'll be shooting.

Research is also essential when it comes to planning your movie, and you should study up on recent films that are similar in content and targeted at the same audience as your planned project. Look at the way the film is shot, the colors, shot types, and angles used. Copying the look and style of an existing film is rarely seen as theft in the world of movies, as long as you don't produce a carbon copy of someone else's movie. You're more likely to hear the word "derivative" than you will "rip off." Your research can easily be performed by browsing the web as well as your local DVD rental store and should be an enjoyable process. Take notes on elements you like and techniques that you think would work well in your film to help with your planning.

If you're using titles in your film, bear in mind where they will be shown. YouTube often adds advertising to the bottom of videos on its website so make sure, if your video is intended for the web, you place content accordingly. The length of your film should also be adjusted depending on where it will be shown. While viewers expect around an hour and a half while watching movies at the cinema, they're less likely to sit in front of a computer screen for that amount of time. Trim your movie to a reasonable length when editing, making sure you include as much detail as possible while keeping the film punchy.

CUTS, SHOTS, SCENES, AND SEQUENCES

During your research and planning, determining the shots you will be using can help you build your film's narrative. Again, making your shots quick and punchy where possible will help move your film along and retain audience interest. A shot is defined as a continuous clip of film and a cut occurs when the video switches to a different clip. For example, in a sequence that shows a panning shot across a beach that then switches to a surfer talking to a friend, the move from the panning shot to the surfer's close up is the cut. The way in which you position your shots and cuts are visual ways to tell your story and can suggest things to the audience without the need for narrative or dialog.

The length of a scene—a collection of related shots and cuts—should last as long as is required to advance the narrative in general, or specifically a character's journey. Very long scenes can quickly bore a viewer, so make sure to only include essential elements. Conversations between characters, for example, don't need to be shown from the very beginning. Cut into a conversation at the point where essential information is discussed to save time by removing the non-essential preamble.

This opening pan sets the scene before we cut to the characters within that location.

STORYBOARDING

If you're after the utmost in planning, you should seriously consider storyboarding your scenes and creating a shot list. Storyboards can help you visualize shots in both your mind and the minds of your cast and crew, and will also help you spot any errors or technical difficulties in advance. You don't have to go all Spielberg in the creation of a storyboard either—a simple word processor document or just a plain old piece of paper will suffice. But if you're looking for a handy digital solution a number of apps exist for the iPhone and iPad as well as for the Mac and PC. Apple's own Pages word processor for Mac offers a storyboard template and there are plenty of free template downloads for other word processors as well. Tamajii Inc offers a brilliant free app for iPad called, funnily enough, Storyboards that allows you to create detailed storyboards with a variety of characters and props so you can lay out each shot. For iPhone users there is iStoryboards that allows for the same documents to be created on the iPhone and accessed while you're shooting.

Whether you opt for a paper or digital storyboard, any form of detailed plan to help you create your movie is a must to avoid unforeseen issues and keep things running smoothly. Digital is often the best way to go as it allows greater flexibility to adjust and update plans as needed and keep your shoot on track and adaptable where necessary.

When it comes to editing your film, the storyboard you created in pre-production will also be of benefit as it will aid you in piecing together your story using the footage you have shot, and help you determine where cuts should take place. This can be especially handy when editing a Pulp Fiction-esque movie where the timeline isn't linear and scenes appear out of sequence. Think of your storyboard as a comic that you can bring to life through your editing of footage. You'll have a far clearer idea of how your movie should look with a blueprint in front of you at the editing stage.

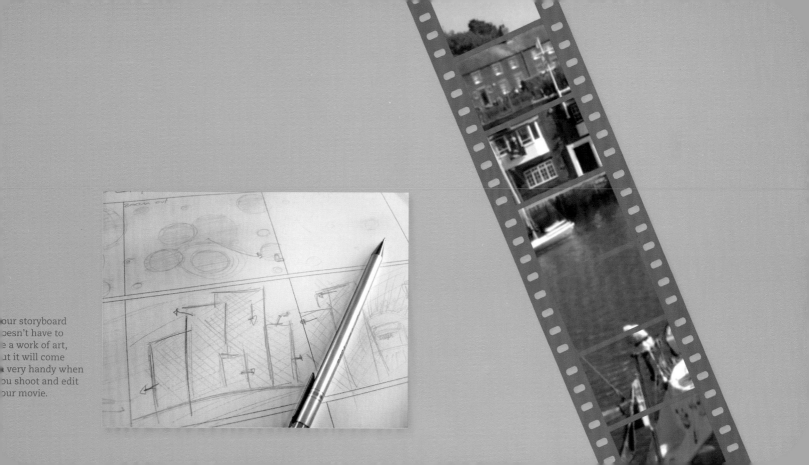

Your storyboard
doesn't have to
be a work of art,
but it will come
in very handy when
you shoot and edit
your movie.

SHOT TYPES

Understanding and researching existing films will help you when it comes to planning your shots. Audiences who regularly watch television and movies have come to expect certain things from the films they watch. If the film cuts to a wide shot of the exterior of a hotel and then to a woman at a reception desk, the audience is conditioned to understand that the woman is inside that building. This is an establishing shot. Of course, not all films adhere to these rules, but there are some generally accepted shots and techniques that viewers will be familiar with, even if they don't consciously realize it. Long shots are used to take in a lot of action in one go, and can feature a number of subjects or a location to give a general overview of what is going on.

A long shot is most often used to establish a setting, be it a busy train station or an office building. It can also include characters, in which case you will be able to see all of them in the shot with room to spare for movement within the shot. The medium shot is closer than the long shot, but not as close as a close-up. It normally shows characters from the waist upward so that they can be clearly identified by the viewer, and their facial expressions and movements can be seen as well as their surroundings. Medium shots are the most commonly used shots in film as they provide a decent payoff between character and background for the viewer. The close-up shot is aimed at putting all the focus on a subject or character so that it is the only thing grabbing the audience's attention without distraction from the background. Close-up shots make it easy to see even very subtle facial reactions from a character and are also handy for use as cutaways.

Rather than sticking to a medium shot throughout a scene, occasionally cutting to a close-up of one or more of the characters involved (a cutaway), breaks things up and keeps things interesting. A cutaway doesn't have to be a close-up on a person, however, it can be used to suggest many things, such as time running out with a quick cutaway to a clock or digital countdown.

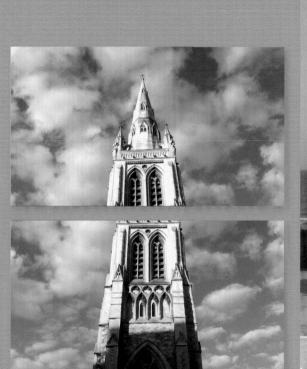

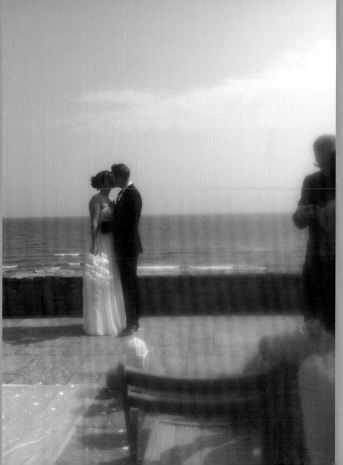

This shot moves down from the spire of a church to establish the location before cutting to a shot of a wedding.

SHOT TYPES

A medium shot allows the audience to see most of a character on-screen as well as recognize his or her facial expressions and body language.

A close-up shot focuses completely on a character or object to avoid any distractions for the viewer as well as showing reactions in more detail.

Quickly cutting away to an object or facial reaction can add interest to your scene and provide a narrative. It also helps keep the viewer informed as to what else is happening in the scene.

PROFESSIONAL POLISH

For that extra level of professionalism in your movie you can make use of tried-and-tested filmmaking techniques that enhance the viewer's experience, as well as making your film easier to watch.

Continuity

If you've ever visited IMDB.com, you'll notice that the listings for each film has a "Goofs" section. Many of these errors spotted by viewers are continuity errors that slipped through a film's production. For example, in one scene in *Top Gun*, Kelly McGillis' ear repeatedly appears both tucked into the cap she is wearing and outside of it during the course of a single conversation.

This is a tiny mistake that very few people (aside from eighties action-movie lovers like me) will spot, but if they are spotted, mistakes like these can distract your audience from the story. Cutting between different shots and angles, and often across multiple takes, is bound to throw up continuity errors, so stay vigilant and make sure that any props you are using don't move mid-scene, or in more extreme cases, that the weather (and therefore lighting) doesn't differ between shots. The same is true of the way you shoot and the quality and exposure of the footage from your iPhone: continuity is key. If you adjust the white balance while shooting a scene, for example, individual shots may appear differently even though, to the viewer, they are supposed to be identical. If this is the case, do what you can at the editing stage to match the two exposures in order for your cuts to appear seamless.

Don't let differences
between shots in the
same scene distract the
viewer from your story.

PROFESSIONAL POLISH

Eyelines

To help guide your audience, a technique similar to the cutaway called an eyeline can be used to indicate that a character is looking at something or has spotted someone. Classic eyeline usage features a character glancing at something off-screen, at which point a cutaway shows what they are looking at, before returning to their reaction. A classic example of a cutaway is a close-up of a character's face while they are driving. A glance upward suggests to the viewer that they are looking at a rearview mirror, and the next shot is a cutaway showing the mirror's reflection, as if from the character's eyeline. An alternative example is a close-up of a character which shows them squinting into the distance, hand shading their eyes, before a cut to a boat or plane on the horizon.

Angle of shot

Audiences also respond, normally subconsciously, to the angle at which you shoot your subjects. If a character is shot from an angle where they seem to be towering over the audience, an idea of power or dominance is suggested, whereas if the audience is looking down on a character the reverse is true. For example, a view looking down on a crawling child offers a feeling of superiority to the viewer, while the child's view looking up at an adult suggests the opposite. To avoid these unspoken suggestions when filming children or animals, the shot can be brought down to their level to promote a feeling of association. For documentary films and factual pieces, the convention is that the angle of shot should be from eye level to remain neutral.

Showing where a character is looking followed by a cut to what they are looking at is a good way to drive a scene without dialog.

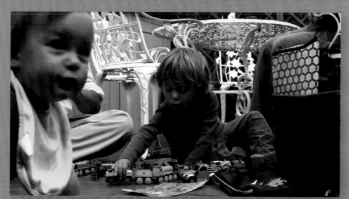

In this shot of two young children playing, the camera had been lowered so that we, the audience, feel like we're on the same level as them, and joining in the fun.

THE CLASSIC MOVIEMAKING STAGES

If you want to follow the traditional route to making a movie, there are five key steps. Even if you don't follow these steps to the letter, understanding how the majority of films are made will help you plan and produce your film in a more professional way and help avoid any of the common pitfalls.

Development

The development stage is where you begin tailoring your story for the screen. This could mean pulling together the facts you need for a documentary piece, drafting a script from an existing story, or writing an original screenplay. Development should also include any financial plans or fundraising you need to do.

Pre-production

Taking your ideas and scripts to the next level will prepare you for the next stage. This is where you can put together storyboards, scout locations, and plan out when and where you will be shooting.

Production

The point at which you begin actually shooting your movie. If you've completed the first two stages correctly, all that needs to be done is to turn up and shoot at the times and locations you have specified in the pre-production stage.

Post-production

During post-production the film is edited using your chosen software or on your iPhone using iMovie. This is also where you'll add any special effects and a soundtrack to your film.

Distribution

With your film shot and edited, it's now time to get it distributed so it can reach its audience. At this stage you can sell your movie to a distributor in order for them to show it on television or screen it at cinemas, or you can distribute it on your own. This isn't quite as scary as it sounds: there are many online services that allow you to sell movies or DVDs, or you could of course sell the film yourself on your website. This stage will also see the promotion of your film kick in to generate more viewers.

Dedicated screenplay software, such as Screenwriter, helps writers keep track of the technical details and structure.

SHOOTING WITH THE IPHONE

So you've got your phone and you know how to use it, you've picked up some handy additional kit as advised by yours truly, you've learnt to think in the language of film, and you're ready to get out there and shoot a masterpiece. My advice for your very first run is just to do it. Don't think about what's best, don't think about the short film festival awards you could win, just go and shoot anything. The art of trial-and-error has never been more useful than when it comes to shooting with the iPhone, and dare I say it, you'll learn a great deal more while practicing than I could ever fit into these pages. That said, you're probably still after a little guidance, so I'm not about to stop things here. There are still some staples you should adhere to when it comes to getting serious about your iPhone moviemaking and that's what this chapter is all about—the practicalities of shooting on an iPhone.

As I said before, I don't want to constrict you in any way—what works for you works—and that little "shoot anything" jaunt I just suggested will help you to get a better idea of how the process works, and more importantly, to learn that things often won't work out the way you expected. I hope it might also have reinforced a few of the earlier chapters in this book. Were your shots a bit shaky? Was the sound a little distorted? Did you have to get uncomfortably close to somebody you were shooting? See, I'm not just doing this for fun—there are things to be learned here!

Perhaps after your practice run you want to flick back a few pages to refresh yourself on any sections I covered that have now become a blindingly obvious requirement for your shooting. When you're done, head back here and I'll fill you in on a few techniques that will make any shoot go that much smoother.

PREPARING TO SHOOT

I know it can be boring planning to shoot when you could just get out there and start wildly filming things. Preparation, though, is a key part of any successful shoot and regardless of how much like a schoolteacher I sound, you'll thank me (and yourself) for it later. While we are talking about a very simple process— point the camera, push a button, and record—there are a number of things that can go wrong when shooting. This applies just as much to those making serious films as it does to the casual holidaymaker wanting to capture their memories. That little bit of planning could make all the difference to your footage, even just if it's the briefest exploration of your shooting area or deciding on the perfect accessories to take with you. When it comes to filming scenes or memories, the technology should be a secondary thought after the creativity of shooting. The goal is to have every eventuality covered in order that once you're ready to shoot, shooting will be all you have to think about—not "did I pack the right lens?" or "do I have enough battery for this?"

Choose your weapons

First of all, select your accessories. Decide which you will need and which you can do without. Lugging a heavy bag of extras that you end up not using will only make things more difficult. Depending on the type of shooting you're doing, you might be able to get away with just a lens and a microphone for some, and for others it might be a whole bag full of goodies, in which case you may also want to include an assistant (or sherpa) in your plans.

A little bit of planning could make all the difference to your footage, even if it's the briefest exploration of your shooting area or deciding on the perfect accessories to take with you.

A decent shoulder bag with pockets is a must for the traveling filmmaker. I particularly enjoy InCase's offerings.

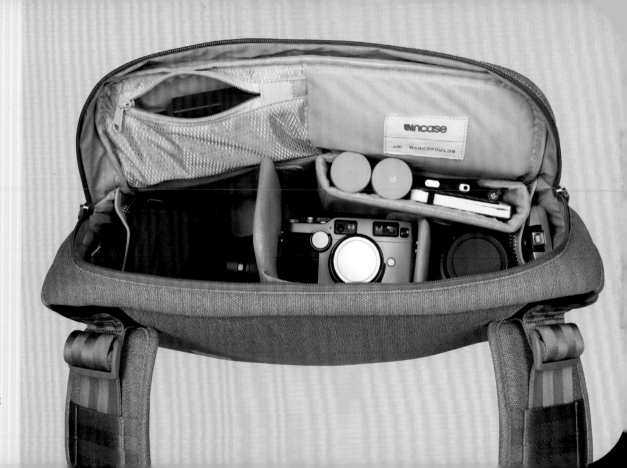

PREPARING TO SHOOT

Charge!

Now you've determined the kit you're taking, you should make sure that any powered devices (that includes your iPhone) are fully charged and ready for the shoot. For extra protection from the dreaded "low power" signal, make sure you pack a portable charger or spare batteries for each device you will be using so you can top up while you're out and about. As I've mentioned already, the iPhone can quickly run low on juice when you're shooting for extended periods and is also the most crucial link in the chain unless you've suddenly turned your attention to live theater. Plan out the length of time you'll be out shooting (or potentially shooting) and factor in the amount of battery you'll likely use.

It's unlikely you're going to find a power outlet to charge from if you're shooting outdoors so I would suggest investing in a device that offers portable charging via USB. One such device is New Trent's iCruiser IMP1000 which, despite sounding like a vehicle from the *Mad Max* movies, offers an incredible 1100mAh capacity. What does 1100mAh stand for? Let's just say it means that you could fully charge an iPad 2 or charge an iPhone up to six times without ever having to visit a power socket. With this kind of power in your arsenal you'll be able to boost your iPhone's battery while you take a break or set up a shot and happily keep going for days at a time, ideal for those times you're shooting in remote locations.

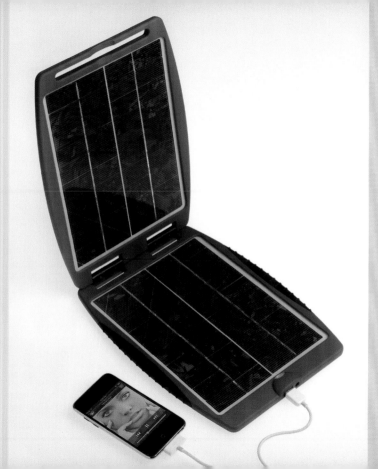

Running out of battery is the worst-case scenario on a shoot. Make sure you're prepared with a suitable charging device.

Talking of remote locations, let's say you're away from power and dealing with baking temperatures while shooting. Using a cunning little device from the guys over at PowerTraveller called the Solargorilla you can harness the sun's rays to charge your devices. Comprising solar panels and a power pack, the device is waterproof, seriously rugged, and can charge a wide range of devices using interchangeable tips or a simple USB connection. Of course you are limited by the weather, but you can also charge the device itself before you leave so the sun merely tops up the power you've already stored. If you're shooting in largely sunny areas, this device is a little gem that is an essential accessory for your kit bag.

PREPARING TO SHOOT

Location, location, location

If you know what or where you're going to shoot, think about any potential pitfalls. What time of day are you planning to shoot? Is it a public place that could fill up with people finishing work at five o'clock or flocks of revelers at ten? What will the light be like during the time you plan to shoot? Is there any building work going on nearby? Are you even allowed to shoot there? For the casual filmmaker these aren't normal considerations, but should you ignore them you could end up with substandard output that could have been so much better if you had planned or timed your shooting a little better. If necessary, create a specific order for your shots so that you avoid busy periods and low-light conditions. For example, if you aim to shoot some shots inside a building as well as outside, make sure you make use of the daylight for the outside shots and shoot the indoors later. Where possible, it's even a good idea to "scout" your locations the day before to identify any issues you may have. This is good practice given that you'll have a clear idea of the environment you're shooting in and may even help you come up with some creative ideas before you even start filming. One other thing you might want to look at is a weather forecast. I know it sounds stupid, but if it's scheduled to rain for the duration of your planned shoot you may end up with footage more akin to *Waterworld* than your intended outcome. Check out my personal favorite, the Accuweather app for iPhone and iPad in order to try and second-guess the weather.

It's a good idea to "scout" your locations the day before to identify any issues you may have. This is good practice and may even help you come up with some creative ideas before you even start filming.

Preparing for shooting is almost as important as the filming itself. Check the location and weather in advance.

©2010 GOOGLE—MAP DATA ©2011 TELE ATLAS, IMAGERY ©2011 GETMAPPING PLC, DIGITALGLOBE, GEOEYE, INFOTERRA LTD & BLUESKY, THE GEOINFORMATION GROUP

SETTING UP YOUR SHOT

You're at the location, the weather is right and everyone's assembled. Whether this is the kids about to jump into the pool or a bunch of actors standing around waiting for the word "action," even the briefest glimpse around your surroundings will help you pick the perfect shot. Unless it's part of the style you're looking for, try to position yourself with the sun at your back to avoid any glare and look out for anything in the background that might pull focus from your subject. By all means go ahead and shoot whatever's pulling focus first if it's more interesting!

You should also try to think outside the box when you pull out your iPhone to shoot. You don't always have to take up the obvious position to shoot from. Think about the viewer: rather than just pointing and shooting, position yourself so that a shot becomes that much more interesting, be it from a low position looking up, a higher vantage point like a balcony, or a little more of a creative shot through plants. Try multiple angles and styles as well—you can always discard them at a later date if they don't work out.

Picking unique shooting angles can add some spice to your finished movie.

LIGHT, SHADOW, AND REFLECTION

While I've already discussed lighting kit you might want to use, there is another lighting issue we're yet to discuss. The oldest of lights: the sun. Most of the time that old burning ball in the sky only adds to our videos, beaming rays of light onto our subjects and producing wonderful lens-flare effects. Sometimes, however, it's not our friend. In addition to blinding those in our clips and causing them to squint, sunlight doesn't like being told where it can and can't go like a studio lamp and therefore introduces shadows into our shots. Shooting with the sun at your back produces both of these negative aspects and so you should be aware of this when you start to record. Try to position yourself in such a way that those you are filming aren't forced to look directly at the sun and also that your shadow isn't cast across them or anything else in your shot. The same goes for glass and water—nobody wants the beautiful illusion they have created in a video shattered by the sight of themselves holding up their iPhone on-screen. For the complete perfectionist, the answer is to shoot earlier or later in the day when the sun isn't at its peak in terms of height and interference, but I know that's not a practical solution for most. Instead, a few steps from one side to the other before you begin recording should be enough to avoid unwanted shadows and reflections and should also be something to bear in mind while you shoot, especially if you're moving around to follow the action.

Shadows can also act as a kind of visual shorthand for the viewer. Here the long, solitary shadow streaming out in front of the woman suggests loneliness or isolation.

Don't let intrusive shadows cast by you and your crew ruin your shots. Make sure you position yourself at an angle to the sun wherever possible.

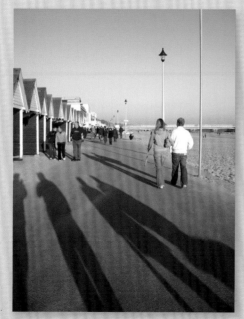

SHOOTING WITH THE IPHONE

Reflections and glare can make some shots look great—just make sure you or your iPhone don't show up on shiny surfaces.

The reverse of this, quite literally, is the reflection and refraction that the iPhone's shiny back can create when facing the sun. I recently discovered this when filming at Wimbledon and I'm pretty sure I put Maria Sharapova off her serve on more than one occasion. The glass front and back of the iPhone can beam all sorts of unwanted light in different directions, so you might want to consider a matte cover for yours if you intend to shoot in bright conditions. Again, positioning yourself out of the direct glare of the sun can help, but it might not always be a possibility.

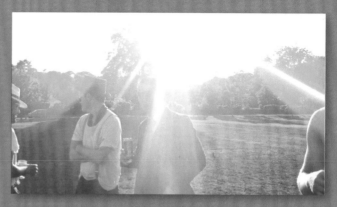

The sun's rays can play havoc with your shooting, but with planning, you can harness the light to great effect.

PANNING

When scoping out your shooting location, your surroundings may well offer up some useful tools to aid your recording. If there's a wall, tree, or table to hand, make use of it to steady your shot when you don't have access to a tripod. Leaning with both elbows on a surface while you film will reduce the amount of shake to a great degree while still allowing you to pan and tilt the camera freely. When placed on a flat surface, it's simple enough to slowly twist the iPhone to produce a panning shot and the resulting shot will be a great deal more stable than without any support.

Obviously, working with a tripod will provide the smoothest panning shots, but if you don't have one available, nor a flat surface, there are techniques to reduce the shakes. Firstly, hold your iPhone with two hands rather than one. Yeah, it doesn't look as cool, but the goal here is to achieve better shots, not to increase your sex appeal. Next, tuck both elbows into your rib cage to form a primitive support to limit up and down movement and almost use your body as a tripod, twisting your torso rather than moving your arms. Finally, make use of a tried and tested technique from the armed forces and control your breathing. Before you start to pan, take in a deep breath, and as you move the iPhone across your scene, slowly exhale. Controlling your breathing helps to keep your body still; however, if you're filming a long shot, this may not be a good idea.

A panning shot like the landscape scene above will be enhanced with a tripod, but a steady hand can work if required.

When placed on a flat surface, it's simple enough to slowly twist the iPhone to produce a panning shot and will be a great deal more stable than without any support.

ADVANCED SHOTS FOR IPHONE FILMMAKERS

Are you itching for more extreme shot types? Fear not. I know there are a number of you who want to get all Jerry Bruckheimer when it comes to shooting with your iPhone, and therefore I present this section, which covers the wonder of dolly, crane, extreme POV, and underwater shots. If you're easily alarmed or are filming your family for the benefit of posterity, the following section on adding effects to your video might be more up your street. Hardcore filmmakers, step this way.

Let's first get something straight. Your iPhone is an expensive piece of equipment that, if broken, could leave you up the proverbial creek without a paddle. If, however, you want to record footage of you whitewater rafting down that creek with your iPhone, I would suggest getting yourself some insurance. Most phone carriers can provide insurance as part of your contract with them, but there are other specialist insurers who cater specifically for gadgets like the iPhone. For a small monthly fee you'll be able to record using any of the methods I'm about to explain, safe in the knowledge that your phone is covered. You, on the other hand, are a different matter, so take care out there.

Flip to page 90 for more on filming underwater.

ADVANCED SHOTS FOR IPHONE FILMMAKERS

The dolly shot

From Scorcese's three-minute journey through the Copacabana in *GoodFellas* to the opening scene from *A Touch of Evil*, the dolly or tracking shot is one of cinema's best-loved techniques. Dolly shots require the camera to be set on a wheeled platform which is pushed along a track in order to follow a subject or pan across a scene, but there's no reason you can't recreate this style using anything with wheels. One of the easiest and most frequently used dolly-shot tools in the indie movie world is, believe it or not, the wheelchair. With the camera operator sitting in the chair to steady the camera, another person then pushes them along a defined route in order to produce a tracking shot. This same method can be used with all manner of wheeled objects, from skateboards to shopping trolleys. Be creative with what you have and impress your audience.

The crane shot

A slow rising or swooping shot can add some real "wow factor" to your project, and you don't need an expensive Hollywood setup to achieve it. An iPhone on a stick will do. Attaching your phone to anything that allows it to be raised and lowered can produce some interesting angles, whether it's a basic tripod or a fishing pole. You could even try using balloons if you can weight the phone enough to stop it spinning around. Alternatively, make use of nearby options to create a faux crane shot. Elevators, escalators, ski lifts, and cable cars are all ways of getting your shot from low to high in one smooth movement.

A professional tracking shot requires a lot of kit, but anything with wheels will do, even a skateboard!

Rather than use an expensive camera crane, this shot was taken from a balloon.

ADVANCED SHOTS FOR IPHONE FILMMAKERS

Extreme POV shots

Strapping your iPhone to anything that moves at speed is always a bit of a risk, but you do get some great footage by doing it. One of the best ways to capture more extreme footage without risking your phone too much is to get hold of a mount and case combination like Biologic's Bike Mount for iPhone 4. This hard-wearing case not only protects your iPhone, but also provides a protected area for the front and rear cameras. The mount is adjustable and as a result can be attached to all manner of vehicles, from bikes to boats, and lets you film as you go. The screen is fully accessible through the case so you can control the camera easily and should allow for a wide range of creative and high-octane angles.

For shots while driving (and here you'll need to take even more care), the simplest route is to get

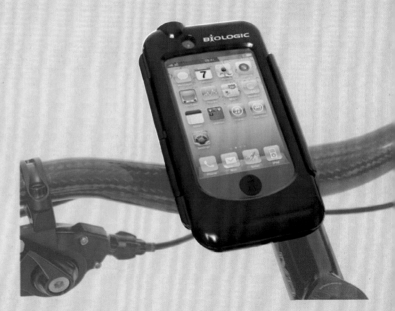

hold of a reliable yet cheap car mount, normally used for GPS apps and hands-free phone calls. These devices, usually mounted via a suction cup, provide an easy way to position your phone within a car, and assuming your windscreen is clean, will allow you to shoot the road ahead using the rear camera. *Top Gear*-style pieces to camera while driving aren't advisable, but are possible by using the front facing camera.

Shooting in a car is best done by a passenger, although an iPhone dashboard mount can also help.

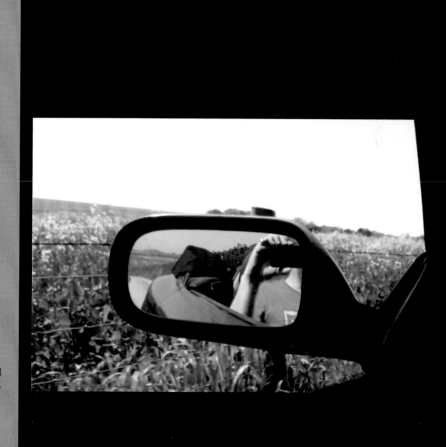

ADVANCED SHOTS FOR IPHONE FILMMAKERS

Shooting underwater

Okay, so now we're getting into crazy territory, but it's perfectly possible to shoot video underwater with your iPhone. But before you run to your local swimming pool, wait just one second. You will need an iPhone-compatible waterproof case, of which there are many available online. Let's also clarify that when I say waterproof, I mean *waterproof*, not splash proof. Many case manufacturers claim protection from water but are really talking about accidental exposure to rain or puddles, not a full-on swim. In order to set about making the next *Deep Blue Sea* you will need a case that not only offers an airtight seal, but one that allows you to film clearly underwater. The waterproof bag-style design isn't ideal for filming, so a case is the best option. Something like The Joy Factory's RainBallet is an ideal solution as it offers Sharpvue lenses at the front and rear for underwater filming. It even uses an Intelli-filter to allow for sound recording underwater

as well. It's worth noting, however, that most waterproof cases aren't designed to go much deeper than sixteen feet underwater, so you'll need to look into more advanced options if you're planning to shoot while diving or even at the bottom of some deeper swimming pools.

A suitably airtight, waterproof iPhone case will allow you to capture exciting underwater shots.

Before you run to your local swimming pool, wait just one second. You will need an iPhone-compatible waterproof case, of which there are many available online.

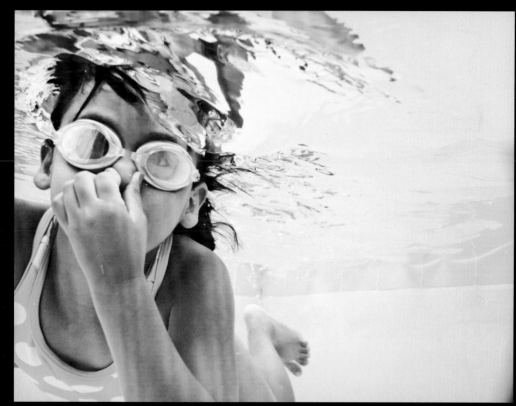

CHAPTER 5

PROCESSING AND EFFECTS

How did your shoot go? If you're following this book in a linear fashion (by no means a requirement but it helps me figure things out), you'll likely have a bank of great clips stored in your iPhone's Camera Roll. For many, this is where clips will stay, destined only to waste space on an iPhone and occasionally be pulled out of the digital dust to show off to friends and family. We don't want that though, do we? No, these clips are the building blocks of your next masterpiece! We'll get on to editing in a little bit, but for now, I want to take a look at one of the most fun things you can do with video on your iPhone: apply effects to your clips. While the iTunes App Store has been known to offer a few dud applications, one sector that continues to impress is photography. Even before the iPhone could shoot video, there were applications that forced it to do so. Now we have that capability on our devices (and in HD no less) developers have really upped their game to bring some incredible video-related tools to the iPhone. In this chapter, I want to look at some of the best options for iPhone video effects, both those that you shoot video with, and those that apply their effects later. These apps aren't as gimicky as you might expect either, with many capable of providing unique styles that just aren't possible with the iPhone camera alone. Others can apply one-off effects in order to achieve a specific look and feel. Some simply make your video look better. Whether you shoot your clip within a specific app in order to use an effect, or apply the effect later, the clips can always be saved to your Camera Roll so you can add them to your final project whenever you need. Just make sure you have enough space available on your iPhone, or decant clips to your computer regularly to avoid being caught out.

PROCESSING AND EFFECTS

One of the best uses I have found for video effects, outside of achieving a particular aesthetic, is to use them to cover up grainier or out-of-focus shots that you still want to use in your project. Where a lack of light or misused autofocus may ruin some shots as part of a crystal clear HD movie, they can be salvaged using any number of effects as part of transitions or titles. I always tend to think of the utterly outrageous TV show *Jersey Shore* when using this trick. The show's editors make great use of a film grain effect for establishing shots and incidental clips with voiceovers. While these clips probably weren't bad to begin with, it goes to show that a little bit of effects trickery is acceptable, even in the mainstream. If you do have a shot that's unusable on its own, a little film grain will make it look like that was the intention all along. Of course, you'll need to repeat this effect with other clips in your project, or else people will wonder why only one sequence received this treatment.

Elsewhere, effects can be used in conjunction with your movie's narrative for both serious movie projects or more personal family footage. Firstly, there's the point of view shot—be it seen through the eyes of a deranged killer or the family pet—using some cunning video manipulation. You can even splice in "old school" clips to suggest a historic feel using many of the Super-8-style video effects available.

However, those are just a couple of effects possibilities: there are countless more to be discovered as you explore the App Store, with more appearing every day. My favorites are included on the following pages and should give you a good number of ideas for your next project, regardless of the subject or content. Most of these apps include a variety of effects to apply to your footage and some are even customizable so you can fine-tune filters to create the perfect style for the clip you are editing.

1x

SUPER 8

It's hard to believe that this app is a promotional tool for the movie *Super 8*, given its quality. Replicating an old Super 8 camera in software form, right down to its case, the app allows you to shoot clips with the film grain and jumpy qualities you would expect from an old handheld film camera without the ridiculously expensive development costs of using the real thing. Those who've used photography apps like Hipstamatic will know all about the setup here; swipe the camera's lens to choose specific styles such as black and white and sepia, and hit on-screen buttons to vary the camera effects, which include a frame-shake effect that triggers when the camera is moved. Whether it's a sun-kissed retro look for reflective moments in your movie, more sinister *Lost*-style CCTV, or even film noir you're after, Super 8 is a great choice. You will need to shoot within the application, but clips can quickly be exported to the iPhone Camera Roll or emailed as video files ready to be dropped into your project.

IMOTION HD

If you're after a more unique approach to making movies, check out the iMotion HD app that allows you to create stop-motion animations and time-lapse movies. The time-lapse feature is ideal for montage shots and stop-motion can introduce some exciting effects to your films that aren't possible using a traditional recording method. Best used with a tripod or mount for your iPhone, iMotion HD allows you to set a time-lapse interval and shoot a scene over time, so that you can position your iPhone in front of any subject—a street scene or flowering plant for example—and let it record an image every few seconds to piece together as a time-lapse clip. For movie use, this time-lapse style can be used as an indicator of time changing by shooting a scene where the brightness moves from dark to light or vice versa, or simply to speed up an event that would normally take too long to show in its entirety. Stop-motion can be used for *Transformers*-like animation effects, and is a handy way to get inanimate objects moving.

FILMIC PRO

There are few apps out there that could tempt you to ditch the iPhone's default camera app altogether, but FiLMiC Pro might just be the one. Adding a ton of new video features to the default iPhone offering, the app allows the user to control focus and exposure, change the frame rate and resolution, add overlays, and even use a digital slate for recording takes. One of the most useful features of FiLMiC Pro is its dual reticle system, which allows you to set the exposure and focus of a shot by positioning each reticle over a desired area in the frame. For example, you might want the shot to focus on the petals of a plant, but base the exposure of the shot on the sky behind it. By dragging the focus reticle over the plant and the exposure reticle to the background, you can fix these settings and continue shooting as you desire. You can also lock in white-balance settings to prevent the camera from automatically adjusting colors as you film.

The focus reticle is also ideal for blurring out backgrounds when you want the emphasis on a particular area of your shot. This method can lead to some very professional looking shots, normally only available to those with high-quality equipment and lenses. You can even adjust the focus mid-shot in a far smoother way than you can with the iPhone Camera app's Tap To Focus feature. Using FiLMiC Pro in this way, you can quickly draw the viewer's eye from one point of focus in your shot to another without having to move the camera or change shot.

With so many exciting features, FiLMiC Pro is probably the best video app for those serious about shooting video on their iPhone, and could easily become your preferred option when shooting movie projects with your device.

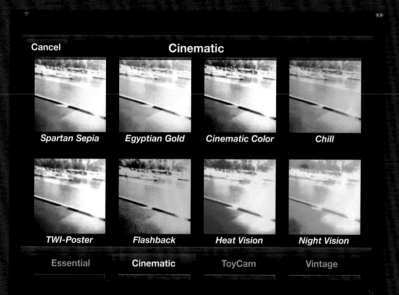

Adding a ton of new video features to the default iPhone offering, the app allows the user to control focus and exposure, change the frame rate and resolution, add overlays, and even use a digital slate for recording takes.

PROCESSING AND EFFECTS

CINEMAFX FOR VIDEO

For applying effects to video you have already shot, CinemaFX is a superb option with a wide range of customizable effects available. Ranging from simple effects like black and white through to more detailed cinematic options, CinemaFX allows you to select clips from your iPhone's Camera Roll or shoot them within the app and apply over fifty effects to them. The app caters for up to three effects to be layered on top of each other and then exported in a variety of resolutions via email, or uploaded to YouTube. Clips with effects applied can be compared to the original as you make adjustments, and each effect can be tweaked using a number of criteria such as saturation and vibrance. What's really handy about CinemaFX is that its effects are labeled to suggest the type of effect based on the style you are after. For example, within the Cinematic effects you will find Dark Comic, Flashback, and Surveillance effects among many other specific filters for movie-style shots. The Surveillance effect in particular is an excellent choice to suggest a shot from a CCTV camera in a movie. A must-have for iPhone post-production work.

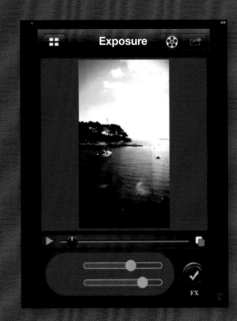

IMAJICAM PRO

For more unusual effects, some of which are pretty trippy, take a look at iMajiCam Pro. These unusual video effects can be applied and changed on the fly, and can introduce some interesting creative options to your projects. A simple interface allows you to pick from a range of effects available and begin shooting by tapping on one of the icons to the left of the screen. The app makes use of the iPhone's built-in flash, and can also apply effects to video from the front and rear iPhone cameras. Most effects can be adjusted beyond their preset settings using simple sliders, and you can even place effects on top of one another to create your own styles. Not all of the effects are designed to help you recreate scenes from *Fear and Loathing in Las Vegas*, however, with more traditional filters also available. Clips recorded within iMajiCam can then be published to the web or sent via email as well as saved to the iPhone's Camera Roll for use within other applications or editing software.

CHAPTER 6

EDITING IN IMOVIE

I'm not going to lie, for the best experience editing your movie, you'll want to export your clips from your iPhone to a computer and import them into movie-editing software. A computer-based editing package like Apple's iMovie for Mac is more powerful and will offer better features than an iPhone app. You could even use footage of this quality in professional-level software like Apple's Final Cut package, Adobe Premier, or Avid. That said, iMovie for iPhone isn't by any means a bad option. As you would expect, iMovie for iPhone and iPad has had to be slimmed down a tad in order that it performs well and doesn't take up a lot of space. It can, however, help you knock together a thoroughly professional-looking film in a very short time. Being a lighter version of the desktop app, iMovie for iPhone aims to do much of the work for you, which if you want it to, is great. You are somewhat limited to a cookie-cutter style, however, and the work created will lack originality, so what I intend to do in this chapter is explain how to take control of iMovie for iPhone and force it to make the movie you want to make.

EDITING IN IMOVIE

You don't have access to funky effects in the iMovie app—for those you'll need to go back a chapter and use other apps to apply effects to each clip before you add them to your project. When it comes to transitions you do have choices, but again, there's not a lot to choose from. Soundtrack-wise you're free to go wild. If it's in your iPhone's music library, it can feature in your movie. If you don't have music on your iPhone you do have options, but they're a little cheesy. Finally, there are titles: again not a lot to choose from here, but they can be tweaked for more unique styles. If you think about it, however, aside from the opening titles and ending credits, when did you last see a lower third or any on-screen text outside of subtitles in a movie?

While it might be nice to include an introductory title and credits at the end of your film, keeping it clean is the most effective route if you want to be taken seriously. Transitions are another area where less is more. Professional movies tend to use dissolves and straight cuts more than anything fancy like wipes which are more often found in TV shows. Fortunately,

iMovie doesn't offer a great deal of choice in terms of transitions, so a straight cut or simple dissolve is likely all you'll be using in your movie anyway.

I tend to use iMovie on the iPhone and iPad to put together quick projects. Creating a snapshot of a larger project for uploading to the web, or even piecing together a short trailer is easy enough to make in the iMovie app and can be uploaded and made "live" from anywhere you have a data connection on your phone. iMovie projects can be sent to a number of online destinations including YouTube, Facebook, and Vimeo, meaning that should you have an account with any of these sites, you can quickly upload and share your movie within minutes of recording it.

Another use for iMovie videos is "iReporting." This recent phenomenon was born from television news channels after eyewitness reports from the public. These networks realize that with the rise of the cameraphone almost every smartphone user is a potential reporter. CNN's iReport is one of the best examples of this technique, and you can upload to the service via the iMovie app for the chance to see your video as part of a live news

broadcast. There's even a template within the iMovie app that allows you to create a video designed for CNN's service.

We'll look at sharing your movies later, but for now it's all about editing in iMovie on your phone or iPad. In order to get going, you'll need, as you should have by now, all of your movie clips stored in your iPhone's Camera Roll with any effects you wish to use applied. If you're still at your location, there's even the opportunity to record additional footage from within the app should you need to fill some gaps.

SETTING UP A NEW PROJECT

Once iMovie has loaded and got its very pretty (but slightly annoying) loading screen out of the way, you're ready to begin. Any previously recorded projects will appear below the neon sign which will change as you swipe between them. In order to create a new project, tap the plus button at the bottom left of the screen.

A new iMovie project screen will now load, and in its infinite wisdom, the app will apply a number of default settings to your project. You might want to keep them, but in the name of true auteurism, you should get in there and mix things up. If so, tap on the cog symbol at the top right of the screen.

Your project will be automatically set to use the Modern theme, with no theme music or titles applied. You can immediately make changes within the Settings screen by swiping a finger across the available themes to land on one you like. Beyond that, use the switches below to turn theme music, and fade-in and fade-outs, on or off. Hit Done when you're ready to move on.

IMPORTING CLIPS

Now it's time to start adding some meat to the dish that is your iMovie project. You'll notice six buttons on the screen, three either side of the editing interface. To add a clip, simply tap the one at the bottom left that resembles a film reel and musical notes. You can now select to view video clips, photos, and audio stored on your iPhone. We'll start with video.

Every video clip in your Camera Roll is shown as a series of frames with clips organized by date. You can quickly flick your way through the available clips, and when you find one you want to add, tap to select it.

When a clip is selected it is surrounded by a yellow outline with a blue arrow in the center. Tapping the arrow will import the clip into your movie in full, or you can use the yellow dots at either end to trim your footage by dragging to set the start and end points of the clip. This is ideal for longer sections of video where you want to pinpoint a specific section to import.

ADDING MUSIC AND SOUND EFFECTS

Music is added in the same way as video clips and photos. From the main iMovie screen, tap on the import button again (the filmstrip and musical note button), and tap the audio button on the next screen.

From here you have access to a selection of ready-made theme music tracks as well as any songs available in your iPhone's music library. You can also access the sound effects section from this screen which includes a bunch of weird and wonderful noises that might come in handy.

When you find the song or effect you are looking for, tap on its title and it will be added to your project as a green or blue bar below your footage.

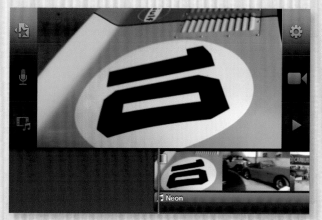

To edit the volume level of an audio track or to delete it completely, double tap it to show the Audio Clip Settings screen.

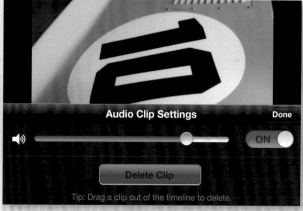

ADDING TITLES

The kind of titles available in your project are defined by the theme you have chosen. Double tapping on an individual clip will show the clip settings screen and from here you can select the Title Style button.

Before you choose your title, tap on Location and enter where the video was shot, or if you're still there, use GPS to pinpoint your location and have it entered automatically. Doing this will give you more title options.

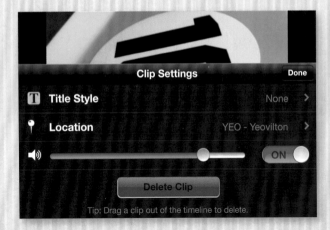

After you tap the Title Style button, the available titles are shown with a preview above. Once you have picked a title you are happy with, click the Done button to be taken back to your project.

A blank title will now appear over the clip you selected. Tapping on this will bring up the iPhone keyboard. Type your title and tap Done to apply the changes. If you selected a location in the earlier step this will also be shown.

ADDING TRANSITIONS

Transitions are also determined by the theme you have chosen and appear between each clip in your video. To customize a transition, double tap on the transition icon (the small square between clips).

The Transition Settings screen allows you to pick a transition type, whether it's the theme-defined option or a simple cross-dissolve effect and also the length of time it takes to complete. Alternatively, you can turn off the transition completely.

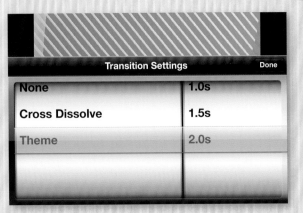

The Transition
Settings screen
allows you to pick
a transition type,
whether it's the
theme-defined option
or a simple cross
dissolve effect.

COMMENTARY AND VOICEOVERS

Tapping on the microphone button on the left of the iMovie interface brings up a small recording menu from which you can begin recording a voiceover. This is ideal for providing a narrative to your movie. It's best to use a microphone here to make sure the audio is clean and clear. You can use the green bars to test the level of your audio input before you begin. When you tap Record, your movie will begin to play back and you will be given a three-second countdown before your recording starts. When you're done recording, hit the Stop button. You'll now be given the option to discard the recording, review it, retake the recording, or accept and add it to your project. Once added, your voiceover will be shown on the timeline as a purple bar that can be repositioned and edited like any other element in your project.

You'll be given the option to discard the recording, review it, retake the recording or accept and add it to your project.

CHAPTER 7

ADVANCED IMOVIE-EDITING TRICKS

So that's the basics of iMovie covered, but, I hear you ask, "How do I make things a little more unique?" It is possible to make your projects stand out from the template crowd with some little tricks that I've found work very nicely and don't require a whole lot of time. While iMovie does like to force you down its own very templated route, with a little effort you can enforce some flexibility in terms of audio, transitions, and titles.

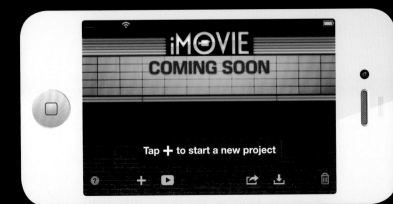

CUSTOM SOUND EFFECTS

With some cunning you can include custom sound effects to the existing library of iMovie sounds. There are, in fact, two ways to do this. Firstly, you can access some iTunes-friendly effects on your computer and sync them to your iPhone's music library via iTunes. Secondly, you can use the built-in recording feature to add interesting new sounds to your project via the iPhone's microphone or an attached device.

A LITTLE PHOTO HELP FROM KEN

When you add images to your project, a default "Ken Burns" effect is applied to them. Effectively a smooth pan-and-zoom across an image to add movement, named after the famous documentary filmmaker, you can edit this setting to great effect within iMovie. Simply select a photo you have added to your project and double tap on it to bring up the Ken Burns settings. From here you can tap on the Start button to choose the starting position and zoom level of the image by pinching and dragging, followed by the end position in the same manner by tapping the End button. Once complete, your photo will move from the start point to the end point over a default four seconds. If you want the movement a little slower, you can extend the duration of the effect by dragging the yellow handle at the right of the clip to stretch it out.

GEOGRAPHICAL GENIUS

The Travel theme, as well as the News theme, in iMovie make use of the geographical information you provided and includes them on a map as part of the titles. As well as your title text, a map view is also shown with the location of the movie highlighted.

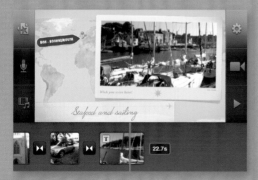

BRING YOUR OWN PHOTOS

As you've seen already, it's quick and easy to add an image to your iMovie project from the import menu, but you're not limited to photos you have taken. You can use any image that's in your camera roll, which includes images you've downloaded from the web. This opens up a number of creative possibilities for cutaways and even adding your own titles using a combination of images and the Ken Burns Effect.

FAST FREEZE-FRAME

Another trick that involves photo imports is the creation of a freeze-frame effect. This easy-to-perform effect suggests to the viewer that a photo has been taken of a scene in-progress. Firstly, you need to pick the clip in your project that you want to end with a freeze-frame: action shots are ideal for this kind of effect. Open the clip in your Camera Roll and pause it on the last frame of the video. Make sure the video controls are hidden and press the iPhone's Home button and Sleep/Wake button at the same time to grab an image of the screen which will be saved to the Camera Roll. Now head back to your iMovie project and import the video clip followed by the photo. Remove any automatic transitions that may have been added and play back your project to check all is working correctly. If all has gone well it should look like a photo was taken at the end of the video as it freezes on the final frame. For the perfectionists out there you can even add a small clip of white as a flash and a Camera Shutter sound effect from the iMovie sound library. If you want to do this, make sure to add a cross-dissolve effect between your white frame and the photos, and adjust the Ken Burns effect to zoom into your image.

You first need to pick
the clip in your project
that you want to end with
a freeze-frame: action
shots are ideal for this
kind of effect.

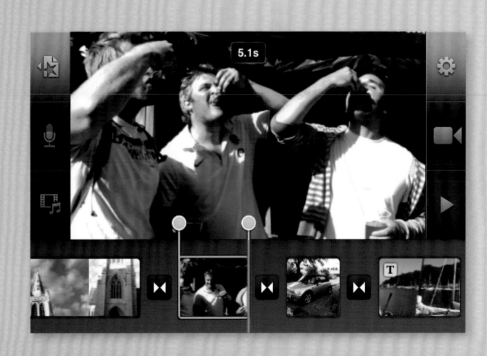

EDIT, EXPORT, AND REIMPORT

This isn't so much a trick as it is a technique that you should really get your head around before you start editing your movie. As I've mentioned before, it's simple enough to use a third-party app to apply an effect to a clip before adding it to your project, and there's no reason to treat iMovie itself any differently. While iMovie has its own selection of themes, you are limited to using one type when editing a project. So, what if you want to use the Neon theme for the opening and closing credits of your project, but cut to the News theme in the middle of it? By default, you can't. So, this is where the method I call "export/import" comes in. It's not rocket science—simply create the segment you want to use in your finished film in iMovie, complete with themes, and export it to your iPhone's Camera Roll as you would any other project. With this small self-contained clip safely stored on your iPhone, you can then drop it into your final movie as if it was any other piece of video. In fact, in the name of safety, you can create your whole iMovie project in pieces using this technique so you can then stick them together when finished rather than run the risk of losing an entire project. Not only will this allow you to use more than one theme, but more sound effects and music tracks too. Finally, working on smaller segments will help keep iMovie running smoothly rather than bogging it down with multiple clips, images, and audio tracks.

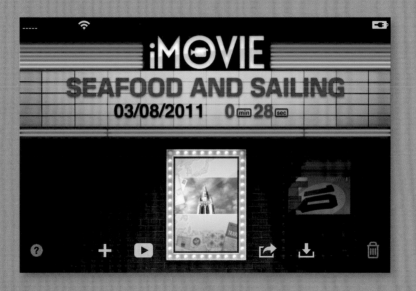

"Export/import" is not rocket science—simply create the segment you want to use in your finished film in iMovie, complete with themes, and export it to your iPhone's Camera Ro as you would any other project.

CHAPTER 8

ALTERNATE EDITING OPTIONS

When you don't have the time to spend editing a full-on project in iMovie, or need to quickly send clips to the web, there are alternatives available. The App Store is full of video tools, many of which are free, that offer basic and advanced editing features as well as a range of sharing options. Below are a few that I think will be particularly handy, especially when it comes to quickly promoting your film, or sharing a trailer of clips with contacts via any of the social networks out there. For sharing, of course, you'll need a connection to the web and movie projects tend to be quite large files, so make sure your 3G data plan is up to the task or find a Wi-Fi network to use instead. Your iPhone can work as

well as a promotional tool as it can an HD camera, so make sure you excite your audience by posting sneak peeks of your footage, or even a full documentary or interview from the set.

For those making keepsake movies for the family, the same is true, but perhaps not quite as important. Teasing your friends with a movie trailer or simply emailing clips from abroad to provide a taste of things to come could be a nice touch.

All of these apps offer benefits when you want to piece together a film quickly without spending a lot of time on a final edit and should be options you investigate if you want a simpler alternative to iMovie.

VIDEOLICIOUS

When you don't have the time to mess around with an entire iMovie project, the free Videolicious app is the answer. The app provides a bunch of templates (including those for sending to major TV shows and websites) that let you tailor your project to your needs. The process of creating a movie is simple too: simply pick your theme, select your clips, choose a soundtrack, and record a quick piece to camera explaining your shots. From here, Videolicious does the rest of the work, intelligently piecing all elements together to produce a polished short film. For a free app, the quality and simplicity of Videolicious is impressive, and it really makes it easy for iPhone filmmakers to create and share quick movies made from their clips. When complete, Videolicious movies can be sent to Facebook or YouTube from within the app, or you can email it to yourself for sharing later.

FLIXLAB

Now here's a clever idea for those shooting with multiple cameras (iPhones in this case). If you shoot using Flixlab for the iPhone, the app can use the power of Facebook to find others in the same area so you can share clips and edit them together. These other people have to be your friends and they have to be using Flixlab too, so some planning does come into the process, but beyond that, usage is pretty simple. It might not be ideal as a method for making full movies, but Flixlab can certainly help you come up with some unique tricks and quick, crowd-sourced movies. By noting your GPS location, Flixlab can tell when you and a friend are shooting in the same location and allows you to share footage between one another via Facebook. You can then access clips your friends have shared and vice versa, which can lead to some nice looking movies with multiple angles. Of course, with clips being shared online, the quality of your original clips suffers and the themes available are a little clichéd. That said, Flixlab offers a handy way to share video between iPhones without having to sync to a computer or share via email so you can quickly build a passable film from any location. Wireless data or Wi-Fi is also a must in order to make the most of the application.

SPLICE

I'd first like to point out that the free version of Splice is identical to the paid version, aside from the adverts that pop up from time to time. If you can put up with the odd bit of marketing you should certainly choose this option. From there, there's a world of editing fun to be had. Not dissimilar to iMovie, Splice follows the normal process of importing or shooting clips and editing them together, but also provides some additional tricks that iMovie doesn't. For one, you can set your project's definition between standard and HD, and can also opt to superimpose a border over your film. Another advantage is the option to set the orientation of the movie, which can come in handy if you shoot a movie solely in portrait or landscape views. Beyond these options you can also add transitions between clips and apply effects to your footage. These effects include a rather handy speed control that allows you to speed up or slow down clips in your movie by using a simple slider. Like iMovie, Splice also offers a collection of soundtracks and sound effects for you to add to your project, and for a free application provides a number of useful editing features that are well worth having on your phone, even if you do already use Apple's option.

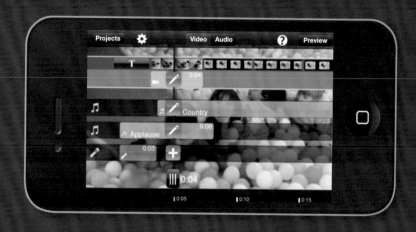

Splice follows the normal process of importing or shooting clips and editing them together, but also provides some additional tricks that iMovie doesn't.

CHAPTER 9

UPLOADING AND SHARING

Once you've finished editing a movie on your phone, it's no good just leaving it there. Your first step should be to save it to your computer so you have a backup, and then you're free to send it out wherever you please, be it to a competition, uploaded to your website, or to a social network. Being an HD movie, you need to look out for any sites that compress your film as its quality will be impaired when shrunk for the web. Uploading from your iPhone is an option, but it's best to send the full quality, finished project from your computer where possible. In this chapter I'll be looking at the various different ways to save your edited project so it's ready to be saved or shared to a location of your choosing.

YOUR EXPORT OPTIONS

There are a bunch of sites and services out there ready to receive your video, regardless of its content. Whether you want to share an eyewitness report, show off your holiday footage, or have your movie project critiqued by others, there's a website available. With domestic Internet speeds increasing every year, uploading even the longest HD movie to the web doesn't take the day it used to and there's little worry about maxing out your usage either. On the following pages are your main export options for movies made on your iPhone. I also recommend you look at the resources section at the back of this book for some ideas on where to send your finished films.

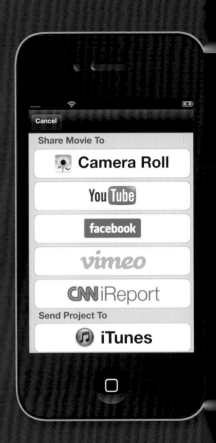

SAVE TO CAMERA ROLL

First things first: you need to get your edited film out of iMovie and into your iPhone's Camera Roll in order to view it whenever you want. This is as simple as heading to iMovie's main menu, selecting the project you want to export, and hitting the share button at the bottom of the screen. From here, select the Camera Roll option and pick the size you want to export at. Obviously, HD is the preferred option here, but if storage is low, you might want to choose a lesser option to conserve space. Once done, your film will be stored on your iPhone and will be available when you launch the Photos app from the iPhone's Home Screen.

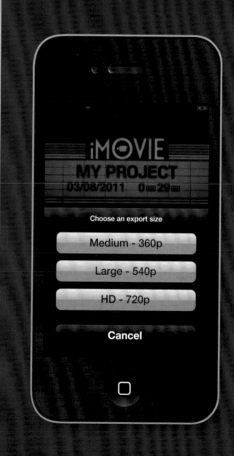

EXPORT TO COMPUTER AND MORE

There are a number of ways to send your movie back to your computer once it has been edited in iMovie. The simplest route is for Mac users, simply exporting the film to your Camera Roll and then syncing your iPhone with the iPhoto application on your desktop to pull in movies to your hard drive. Both Windows and Mac users can also use iTunes to copy movies to their computer. When your iPhone is connected to your computer, head to iTunes and select your iPhone from the Source panel. Under the Applications tab, you can then select iMovie from the application list where all available iMovie projects are kept. Once you've used the Send Project To iTunes function in iMovie on your iPhone, your project will show up in iTunes and can be copied wherever you like. Of course, the project will still be in the iMovie format and not a finished video (use the Export To Camera Roll function for that), but this is nevertheless a useful technique.

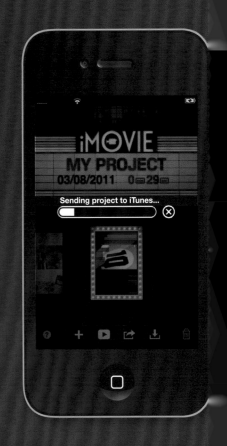

UPLOAD TO FACEBOOK, YOUTUBE, AND VIMEO

As well as pinging your movies back to your computer, you can also send them straight out to the wider world from your iPhone. What was once an unthinkable prospect for publishing movies is now perfectly possible in a matter of taps. Whether you want to share a movie with your friends on Facebook or anyone interested on YouTube and Vimeo, iMovie has the answer. You'll need to own or create an account for each of the services you want to upload to, but from then on, it's almost too easy to send your video to the web. As with the other techniques I've mentioned, heading to the sharing screen, and tapping on the service you want to use (YouTube, Vimeo, etc.) will bring up a set of instructions to upload your video and provide you with a link when it's finished so you can share the video via email or social networks.

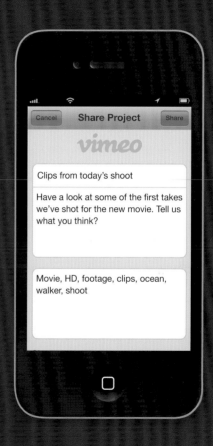

MOBILE NEWS REPORTING WITH YOUR IPHONE

As I mentioned previously, there are a number of websites that also accept footage from the general public as part of their news gathering. The most prominent of these is CNN who accept CNN iReport submissions from their viewers. iMovie itself has a CNN iReport export feature that will do all the work for you when it comes to uploading, and if you do a good job with your video journalism, you could find your work appearing on television. Of course, you'll need to have recorded something newsworthy in the first place. If you've not had the chance to video an exciting piece of breaking news, take a look at the resources section on page 154 on popular websites to submit your videos to. Within iMovie, there are two news themes: one for creating an iReport, and the other a generic template. Both can be used to record pieces to camera or record shots of an event or happening that can be sent to news channels or used as a part of your project. They can also be used to suggest a news report in your film by reimporting a news clip to your project.

SHOW AND PREVIEW MOVIES ON YOUR TV

Rather than burning DVDs, the iPhone offers the unique benefit of being able to send video directly to your TV in a number of ways. The first is to use a cable, available from the Apple Store, that will allow you to plug your iPhone into a television through a component or composite connection. You can then share clips or finished movies from your iPhone straight to the television complete with audio. Alternatively (and at a little more cost), you can make use of the Apple TV, a little box that connects to an HD TV via a HDMI cable. This box connects to your home Wi-Fi network and allows you to wirelessly stream video and audio from your iPhone to your television. Not only do both of these methods allow you to show off your finished movies to others on your TV, it also means that you can quickly preview individual clips or finished movies in order to get a better idea of how they look. The iPhone's impressive screen can sometimes make video look a lot better than the final product so it's always worth checking before you commit to a particular edit.

THE IPAD

Are you one of those lucky folks running an iPhone and an iPad? Well, I'm sorry I've left it so late in the book to tell you this, but almost everything I've explained thus far is also perfectly possible on Apple's tablet. The camera and screen aren't quite up to the mark of the iPhone, but in terms of performance and the applications available, the iPad is more than up to the tasks I've outlined.

I certainly don't recommend using the iPad to actually shoot your movies, but when it comes to editing, sharing, and adding effects to them, the larger screen of the iPad comes in rather handy. When using both devices together you have quite the powerhouse in terms of portable editing (even if you're only previewing movies), and you can also use the iPad as a slate (clapperboard) to mark different takes if you use an app like MovieSlate from the App Store. With your shot information, plans, and storyboards gathered on your iPad, you free your iPhone for the simple task of shooting, which will not only save on battery but make your shoot a lot simpler.

For those of you who don't have an iPad, but are serious about making movies using the techniques I've described, it would be in your interest to get hold of one, especially since once you import your clips onto it you have a backup of them on another device should the worst happen.

However, using an iPhone and iPad to shoot and edit your movies normally requires a computer in between the two devices in order to transfer clips. The alternative is to invest in paid options that allow a direct connection between the iPhone and iPad, such as Apple's Camera Connection kit (pages 146–147) or the Photo Transfer App (pages 150–151).

SHARE IMOVIE PROJECTS BETWEEN IPHONE AND IPAD

1 Start by connecting your
iPhone to your computer
and launch iTunes if it hasn't
started already. Now select
your iPhone from the iTunes
Source panel on the left
of the interface.

2 Click on the Apps tab at the top of the screen and scroll all the way down to the File Sharing section. Now, locate iMovie from the list of apps and select it.

3 Now launch iMovie on your iPhone and scroll to the project you want to share. Tap on the Share button (rectangle with an arrow). Then on the next screen, tap on the iTunes button at the bottom.

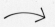

SHARE IMOVIE PROJECTS BETWEEN IPHONE AND IPAD

5 Now plug your iPad into your computer and select it from the iTunes Source Pane. As before, head to the Apps tab and locate iMovie from within the File Sharing list.

4 Head back to iTunes and you'll see your project included in the list of available files for iMovie. You can now save this file to any location you wish on your computer by clicking the Save to... button.

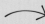

7 Now head to iMovie on your iPad and tap on the import button (downward arrow). You will now be able to choose from all available iMovie projects and add them to your iPad.

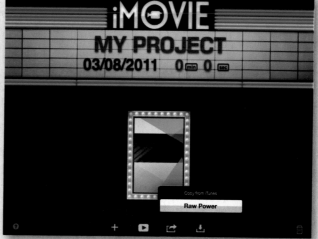

6 Click the Add... button and find the iMovie project you copied from your iPhone. Click on Open to add it to the files list.

SHARE CLIPS BETWEEN AN IPHONE AND IPAD

If you haven't got an iMovie project to share with your iPad, you can quickly send clips across as raw footage and create a new iMovie project on the larger screen. Either export the clips to your computer and then sync them to your iPad via iTunes, or if you want a slower but wireless option, you can choose to email the files at their full quality to yourself (or to the account you use on your iPad) and access them that way. If, however, you want to invest a little money in transferring your videos between the two (a good idea if you're planning to use it frequently), there are a further couple of options. The first is to get hold of Apple's Camera Connection kit which allows you to connect the iPhone and iPad via a standard dock connector cable. This will allow you to quickly transfer all the video you wish from iPhone to iPad, wherever you are. Finally, as is the case with most things Apple,

"there's an app for that." The simply named Photo Transfer App is a universal tool (you only need to download it once to use it on both iPhone and iPad) that allows you to wirelessly share photos and video between devices. While transfers aren't particularly quick, especially when you're copying multiple files, this is a handy solution when you have an available Wi-Fi network.

SHARE IPAD AND IPHONE VIDEO CLIPS
WITH APPLE'S CAMERA CONNECTION KIT

1 Start by connecting the USB part of the Camera Connection Kit to your iPad and attaching the USB end of your dock connector cable to it. Now attach the dock connector end of the cable to your iPhone.

2 The Photos app should now open on your iPad and allow you to select images from your iPhone to import.

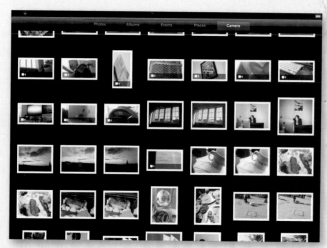

SHARE IPAD AND IPHONE VIDEO CLIPS
WITH APPLE'S CAMERA CONNECTION KIT

3 Select individual images from the iPhone and tap on Import Selected or choose the Import All option to copy over all photos and videos should you have enough space available on your iPad.

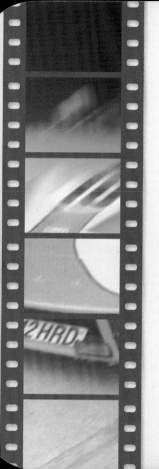

4 Images and video clips you transfer will be stored in your iPad's Photo's app, ready to be used in your iMovie projects.

While transfers aren't particularly quick, especially when you're copying multiple files, this is a handy solution when you have an available Wi-Fi network.

SHARE IPAD AND IPHONE VIDEO

WITH THE PHOTO TRANSFER APP

1 Start by launching Photo Transfer App on both your iPhone and your iPad and press the corresponding tabs at the top of each display to choose which device is sending and which is receiving.

2 Tap on the Device button at the bottom of the screen on your iPad's display and you should see your iPhone listed. If more than one device is shown, select the one you want to use.

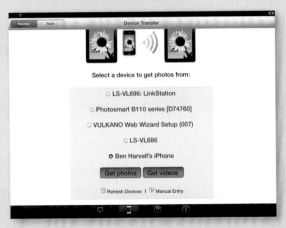

4 Browse the available images and video and tap on those that you want to transfer. When you are ready to transfer, tap Done.

3 On your iPhone, tap on the same Device button and then the Select Photos and Videos button to show your iPhone's Camera Roll.

5 Head back to your iPad and tap on the Get Videos button to begin the transfer from iPhone to iPad. When finished, your videos will be stored in your iPad's Photo's app.

CHAPTER 11

GO MAKE YOUR MOVIE!

You've surely heard enough from me by now. Well, almost enough. I hope, assuming once again that you've read this book from start to finish, that you've learned a few tricks and are excited about making movies with your iPhone (if you haven't sneaked a few attempts in already). By now, you'll have figured out how this whole process works and also have the knowhow to avoid some of the more common mistakes of the amateur filmmaker. So there's little left to do but get out there and make your movie. Given that you bought this book and (I hope) read this far, you're probably interested in doing a little more than just shooting a video to watch at home. I might be wrong, and if that is indeed the case, I hope you get the well-deserved pats on the back from family and friends when you show off your creations. For the rest of you, this is just the beginning. Knowing what to do with the excellent camera housed in your phone, the right accessories to buy for it, and the way in which you can enhance your shots is the first step on a long journey.

Every time you pick up your iPhone and access the Camera app or another piece of movie software you're learning about the process. You learn what lighting is best in different situations, how to keep the quality of your footage pristine and in focus, and more importantly, you learn how you shoot movies: your style and what you find comfortable when shooting. Aside from my time spent writing for and editing various tech and creativity-focused magazines and websites as well as in-depth testing of Apple products, that's how I learned the most about shooting with the iPhone—by simple trial and error. I learned even while writing this book. Now the rest is up to you.

The resources section on page 154 lists a number of sites you could send your videos to as well as competitions to enter and I urge you to do so. If you're proud enough of your movie to show it to other people, then you should certainly be showing it to strangers who could reward you for your work. It could lead to big things.

Without a doubt, the iPhone will continue to improve. The camera will continue to be boosted over the coming years and storage and connectivity will also be enhanced. Because Apple is dedicated to a smooth and consistent mobile operating system, controlling the camera is unlikely to change a great deal bar some new features. So, if you're comfortable with the way things work now, you'll be set for long-term use. I'd love to sit here and speculate on how things are only going to get better for the iPhone filmmaker, but I'm sure you've had enough by now. Let's just settle on the fact that it will. For now, all that's left for me to say is that I wish you the best whatever you intend to shoot and edit with your iPhone and I hope this book will provide you with the expertise and ideas to achieve your goals.

I've tried to reach two different audiences throughout these chapters, both with ambitions for their iPhone movies: the family moviemaker and the serious amateur. With any luck, those in the first audience might be considering switching their allegiance now they've learned how easy moviemaking can be.

RESOURCES

When you've finished making a movie, there are far more sharing options than YouTube alone. While it is the video-sharing site of choice for the current generation and does provide a nice home for your movies, there are many other options on the web. It's perfectly acceptable to use YouTube and it does offer a number of great features—HD quality and website embedding to name a couple—but you won't always find your audience. If you do wish to use YouTube, make sure you become an active user within the community you are after, subscribe to channels, and create your own as well as linking to your video at every possible opportunity. Slowly but surely (or quickly if you're lucky), you'll begin gathering views as well as feedback if you allow comments to be made. Comments are, for the most part, the thoughts of the general public, which are great to have, but usually unqualified. If you're hitting thousands of comments and views, however, there's a real chance of your video going viral and picking up even more views. If your video begins to generate discussion, the word of mouth could be your ticket to Internet stardom. That situation is rare though, and you're more likely to pick up buzz by getting yourself involved in competitions or on dedicated sites for moviemakers where you'll also receive professional critique. Promoting your movies with the backing of a few awards or nominations is a big selling point and should help you qualify for further competitions.

On the right is a list of some competitions and sites you should have a look at if you're serious about sharing your movies. Even if you don't choose to enter, watching videos submitted by others will give you a good idea of just what's possible when shooting with the iPhone and provide a great deal of inspiration.

Resources

The Original iPhone Film Festival
www.originaliphonefilmfest.com
As the name implies, this competition is for iPhone, iPod touch, and iPad users only and offers some great prizes to boot. With a panel of industry experts judging entries, this is a great festival to get involved in and help get your name out there.

Online Video Contests
www.onlinevideocontests.com
This is a good site to check in on from time to time that lists a wide variety of online video contests for you to enter. Search by contest type, location, or if you're the mercenary type you can even view competitions based on the prize.

DepicT!
http://www.depict.org/competition/
As part of the Encounters International Film Festival, DepicT! offers great prizes, as well as exposure to its winners. Films are limited to a minute and a half in length and previous judges include Peter Jackson and Damien O'Donnell.

Indie Short Film Competition
www.indieshortfilms.net
Cash, software, and a bunch of moviemaking kit awaits the winner of this online film festival. Scriptwriters are welcome to enter the competition as well.

iPhone Film Festival
www.iphoneff.com
The iPhone Film Festival site is worth visiting just to check out some of the incredible films made on the iPhone. The competition also offers great prizes and exposure to winners in a variety of categories.

Indie Fone Film Fest
www.indiefone.com
Any phone with a camera is permitted in this competition and the iPhone should serve you well enough. International entries are welcome and the top prize makes it well worth a shot.

YouTube
www.youtube.com
A staple for movie sharing online, if you're not using YouTube already you really should create an account. New features are added regularly and videos are very easy to share online.

Vimeo
www.vimeo.com
As an alternative to YouTube, Vimeo is a slick video sharing service that, when using the premium plan, allows you to ready your videos for viewing on iPhone and iPad as well.

GLOSSARY

iOS
The operating system for the iPhone, like Windows for PC, and Mac OS X. New versions of the operating system bring new features and security fixes.

Angle of shot
The angle from which the camera shoots a particular subject, such as from below or from above. Angles from below often used to suggest the prominence or power of a particular character, whereas for factual programs convention states the angle should be straight-on.

App
An application that runs on the iPhone, normally downloaded from the App Store.

App Store
Apple's online store for iOS applications. Can be accessed from the iPhone or alteratively via iTunes on your computer.

Close-up
A shot that shows only the subject with little or no background. Most often used for showing an actor's facial reactions and expressions in a scene.

Continuity
The act of maintaining a consistent look between shots and scenes. This can apply to props, actors, and camera settings such as exposure and lighting.

Cropping
The act of eliminating space or removing part(s) of an image to improve composition, reduce image size, or change aspect ratio. Cropping can be adjusted with most photography apps.

Cut
The act of shifting from one shot to another when editing a film.

Cutaway
A jump in your footage from a traditional shot to another object, person, or view.

Establishing shot
A piece of footage in your film that sets the scene in order to let your audience know where the upcoming action will take place.

Exposure
The amount of light used to create an image. An overexposed image is created with excessive light, resulting in loss of detail, a washed-out appearance, and blown-out highlights (solid white areas). An underexposed image is created with minimal light, resulting in a dark image with excessive shadows. Exposure can be adjusted with most photography apps.

Eyeline
Shooting a person, object, or view to suggest the viewpoint of a character. Normally used as a cutaway after showing the character looking at something.

Facebook
A popular social networking utility used by hundreds of millions of users, and operated and owned by Facebook, Inc. The Facebook website and app enable individuals, groups, organizations, and businesses to connect and share information and content (including photographs) with each other online.

Flickr
A popular image-hosting utility with a social networking element, operated and owned by Yahoo!. The Flickr website and app enable individuals and groups to connect and share information, photographs, and video with each other online.

Filters
Automated, digital visual effects that adjust the color, texture, aspect ratio, and/or style of photographs. Filters might adjust one or multiple aspects of an image. For example, one filter in a photography app might apply preset saturation, contrast, and vignette adjustments.

iMovie
Apple's video-editing software available on Mac, iPhone and iPad. iOS versions can be downloaded from the App Store.

Medium shot
A shot, normally of a character in a film, that is close enough to read their facial expressions, but distant enough to show the background of the shot.

Mic
Abbreviation of Microphone.

Perspective
The way in which objects appear to the eye based on their spatial attributes. Perspective also refers to the photographer's position and chosen depth of field relative to the composition.

Photo Library/Image Library/Camera Roll
The "Photos" app preinstalled on the iPhone. It stores albums comprised of all images on the iPhone. With this app, users can view, select, present, share, copy, and delete images on the iPhone.

Scene
A collection of shots and cuts, often focused on one location that advances the narrative of a film.

Shot
A single continuous section of footage in a film.

Social network
A structure or tool used to connect or display connections and information and/or content between individuals and/or groups based on interdependency, commonality, or mutual interest.

Storyboard
A visual outline of a film created digitally or on paper. A storyboard is made up of a panel or series of panels outlining the scene sequence along with images and text explaining the action that will be shot.

Twitter
A popular social networking utility and microblogging service owned and operated by Twitter, Inc. The Twitter website and apps enable individuals to share information with followers in the form of 140-character "tweets."

INDEX

Acknowledgments

The editing process can make or break your film and the same is true of writing a book.

Without the unwavering skill of a very talented team at Ilex you wouldn't be reading these words. My thanks go to Adam and Natalia for trusting in my talents enough to allow me to write this book, and to Zara and Tara for facilitating its speedy delivery while making me look better than I actually am. Doreen should also receive credit for putting up with my many irritating emails.

Finally, thanks, as always, go to Hayley who, despite not being a writer or hardcore techie, manages to understand and reduce my stress levels during the writing process.

Picture Credits

Fotolia (www.fotolia.com): p79; p83.
Google (www.google.com): p75.
iStockphoto (www.istockphoto.com): p7; p37; p39; p43; p50; p80; p91; p93, p119; p127.
Photocase (www.photocase.com): p27; p53; p65; p103.
Stock.XCHNG (www.sxc.hu): p57.
Equipment shots courtesy of Action Life Media, Apple, Audio Technica, Biologic,
Canon, Cisco Systems, cowboystudio.com, creativelight.cz, goincase.com, IK Multimedia, JOBY, The Joy Factory, maplin.co.uk, Mobile Mechatronics, Monster®, New Trent, Photojojo, Power Traveller, USB Fever, Studio Neat, Vericorder, and XShot.

About the Author

Ben Harvell is a freelance journalist who writes for the international Mac press as well as books like this one. A regular contributor to *Macworld*, *MacFormat*, *MacUser* and *MacLife*, he was formerly the editor of *iCreate* magazine and has been using Macs since he could afford one. When the iPhone was announced in 2007 he was somewhere in the middle of the crowd in San Francisco realizing the tech world was about to change. Since that day he's written about Apple's phone and its subsequent iPad and has become what some might call an expert in the field. Author of *The iPad for Photographers* and a selection of other iPhone and iPad-related titles, Ben once had the pleasure of standing less than three feet from Steve Jobs at a press event in London.